KEYS TO SUCCESSFUL LANDSCAPE PAINTING

KEYS TO SUCCESSFUL LANDSCAPE PAINTING

WATSON-GUPTILL PUBLICATIONS/NEW YORK

Copyright © 1976 by Watson-Guptill Publications

First published 1976 in the United States and Canada by Watson-Guptill Publications
a division of Billboard Publications, Inc.
1515 Broadway, New York, N.Y. 10036

Library of Congress Cataloging in Publication Data
Caddell, Foster.
 Keys to successful landscape painting.
 Includes index.
 1. Landscape painting—Technique. I. Title.
ND1342.C27 1976 751.4′5 75-38901

ISBN 0-8230-2579-9

Manufactured in U.S.A.

First Printing, 1976

5 6 7 8 9/86 85 84 83 82 81

*To June, without whose help
this book and this life
would not have been possible.*

A success is one who decided to succeed and worked
A failure is one who decided to succeed and wished

—Wm. A. Ward

Contents

Acknowledgments 11
Foreword 13
Preface 15
Introduction 19
Materials 21

PROCEDURES 25

Designing the Canvas 26
Laying In Tonal Values 27
Indicating the Lights 28
Pulling It Together 29
The Finishing Touches 30

ILLUSTRATION 33

Directional Lines 34
Tonal Interest 35

DRAWING 37

1. Redesign Your Subject Whenever Necessary 38
2. Look for the Dramatic Possibilities of an Unusual Vantage Point 40
3. Include Only One Center of Interest in a Painting 42
4. Understand and Apply the Rules of Perspective 44
5. Prevent the Viewer's Eye from Leaving the Picture 46
6. Guide the Viewer's Eye into Your Painting with Directional Lines 48
7. When in Doubt, Simplify Your Design 50
8. Vary Your Solution to the Same Subject 52
9. Occasionally Tell a Story in Your Painting 54
10. Simplify Areas to Accentuate Detail 56
11. To Bring a Painting to Life, Include a Figure 58

LIGHT 63

12. Choose the Best Lighting for a Subject 64
13. Play Lights against Darks, not Color against Color 66
14. Group Lights and Darks to Avoid a Spotty Painting 70
15. Limit the Amount of Light in Some Paintings 72
16. Make the Focal Point a Tonal Climax 76

SHADOWS 79

17. Emphasize the Dark Shadow Sides of White Buildings 80
18. Utilize the Decorative Cast Shadows of Trees 82
19. Make Shadow Directions Consistent 84

20. Paint Luminous Shadows 86
21. Paint the Foreground in Shadow for Dramatic Lighting 88
22. Dramatize a Composition by Adding Cloud Shadows 90
23. Emphasize the Foreground by Placing the Background in Cloud Shadows 92

COLOR 95

24. Achieve Tonal Harmony by Departing from the Literal 98
25. Perceive the Colors in White Snow 100
26. Achieve Harmonious Color through Restraint 102
27. Create Atmospheric Distance by the Use of Color 104
28. Introduce Warm Colors into a Summer Painting 106
29. Paint Moonlights with More Colors than Blue 108
30. Observe More Colors than Blue in Water 110
31. Paint Cool Shadows to Make Sunshine Sparkle 112
32. Perceive the Colors in White Clouds 114
33. Make Patterns of Sunlight on Buildings Point toward the Sun 116
34. Exploit Wind Ripples on Water 118
35. Darken the Adjacent Sky to Dramatize a Light Object 121
36. Choose Backlighting for Dramatic Effects 122
37. Design Roads in an Interesting Way 124
38. Place Horizon above or below the Middle of the Picture 126

SPACE 129

39. Diminish Sizes to Create Greater Depth 130
40. Diminish Values for a Feeling of Distance 132
41. Create Depth by Strengthening Foreground Detail 134
42. Maintain Distinct Spatial Planes 136
43. Try Placing the Focal Point in the Distance 138
44. Keep Distant Water below Eye Level 140

TREES 143

45. Make Tree Shapes Varied and Interesting 144
46. Relate Tree Trunks and Branches to Whole Tree 146

SKIES 149

47. Keep the Sky Lighter on the Side of the Source of Light 150
48. Make Skies Interesting without Competing with the Landscape 152
49. Paint a More Dramatic Sky than the One Actually There 154
50. Vary Cloud Shapes for Better Design 156

Conclusion 158
Index 159

ACKNOWLEDGMENTS

As with most endeavors, there are many people behind the scenes who deserve recognition and credit for their assistance, and I would like to express my gratitude and appreciation to the following:

The wonderful instructors, who did so much to help me along the way.

Don Holden, who suggested that I do this book.

Diane Casella Hines and Claire Hardiman, for their enthusiastic help and logistical organization.

Jeremy Dodd, for his many hours of patient photography.

My wife, June, who checked the text and typed the manuscript.

All my students, who have taught me so much in the process of my teaching them.

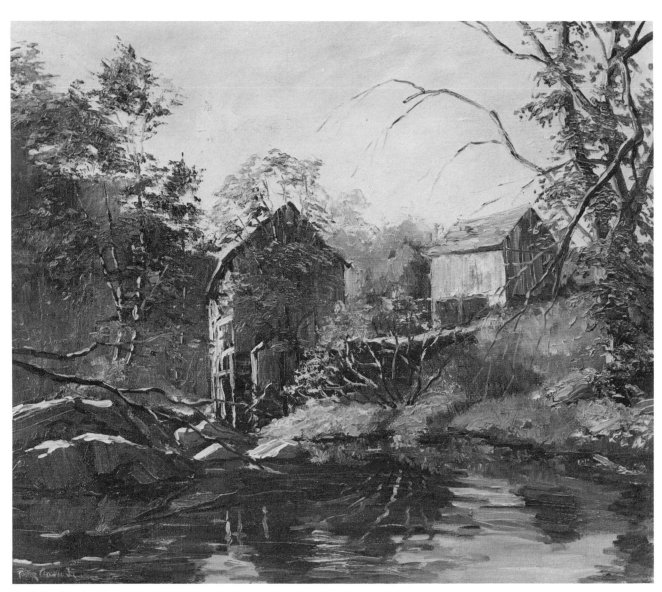

THE LEWIS MILL. *Oil on canvas, 20″ x 24″.*

Foreword

I take pleasure in writing these few lines. Foster Caddell was the most promising of my fifty or more students during my brief career as teacher from 1948 to 1952. Caddell, who had been an Air Force artist in the Far East between 1944–46, was now employed by a lithograph company in Providence, Rhode Island. Though this was a profitable affiliation, a life job so to speak, this young man's burning desire to be a freelance was obsessive. But he was married. There were obligations. Did I think he was ready to make this decisive step? As his instructor and witness to his developing talents, his terrific drive, and his high ideals, by 1950 I could answer in the affirmative. And I was sure he had chosen the right girl for his wife—as a team they couldn't miss.

Accordingly, Caddell was soon engaged in illustrating juvenile books and school textbooks, and producing drawings and paintings for educational programs sponsored by Protestant, Church of England, and Mormon religious organizations. As with Norman Rockwell in Stockbridge, Massachusetts, the models for all such work were friends and neighbors in his own bailiwick, Voluntown, Connecticut. The lone artist in any small community achieves a degree of notoriety. Thus, during his freelancing career—by which time he had already won fine arts awards in Norwich and Ogunquit exhibitions—Caddell was approached by a few enquiring locals sufficiently curious and interested to suggest being taken on as students. Here was another decision confronting the team Caddell. They obliged. Teaching, for Caddell, meant going to nature, seeing and sensing the subject in its fullest, be it still life, figure composition, portrait, landscape, or whatever. This precept, absorbed during his studies under Robert Brackman, Guy Wiggins, and myself, would now be passed on to this handful of hopefuls. The Caddells perhaps did not realize that they were opening the doors to a whole new way of life—teaching at "Northlight."

The once-grand profession of illustration was facing a gradual fade-out. The monthlies and weeklies that had been a major market were disappearing. Budgets for advertising art were increasingly being allotted to television commercials. What was left was being taken over by the camera. But during this transition the so-called fine arts (however defined) were rapidly gaining in audience and sales appeal. Tuned in to this accelerated concern with culture were art schools, art-supply companies, and magazine articles. They promoted a nationwide search for sleeping talents; once aroused, almost anyone could learn to paint presentable pictures.

So, using their native New England sense of values, the Caddells calculated the pros and cons. Illustration had been profitable but now had a dubious future. In addition, such assignments usually have imperative deadlines that too often preclude personal work for one-man shows and fine arts exhibitions. Teaching, if properly organized, would afford this opportunity, and the ever-increasing student applications to sign up at "Northlight" certainly seemed to encourage expansion and development of the school. Another factor was the negotiation of the first of several important portrait commissions, that of Senator Thomas Dodd of Connecticut.

The die was cast. Teaching would replace illustration as a basic source of income. With some astute organizing, the school (for such it soon became) would function for three very full days each week. There would be three classes, the first starting at 9 a.m. and the third ending at 10 p.m. on each of these three days. At this writing 135 students are enrolled, necessitating the addition of a new 20' by 30' studio. This extension, fortunately, caused no loss of the charm of the original layout. Not all instruction is held within the confines of the studio. In fair weather the classes plant their easels on sites known to Caddell for their esthetic or dramatic appeal. Says this phenomenally hard-working instructor, "Everyone in my classes is taught with the same profound interest." Knowing Caddell's integrity, this is no overstatement.

Given four full days now for self-advancement, the same drive that propelled him from obscurity still persists. As a painter, one must view Caddell as a traditionalist. Those masters highest in his esteem are Caravaggio, Velázquez, Rembrandt, Vermeer, and the later Degas, Monet, Sargent, and Brangwyn. Thus his many awards have been in group shows in which respect for the traditional values still prevails. He has shown at the National Academy, the American Watercolor Society, Springfield's Museum of Fine Arts, the New Britain Museum of American Art, and in other important annuals which, so to speak, "hold to the lines."

At age 54, Caddell's accomplishments as both artist and teacher have been recognized by *American Artist* magazine, by Wendon Blake in his book, *Creative Color*, and by Marquis' *Who's Who*. His travels include the Far East, Europe, and Mexico. In my own career of 64 years I've personally known many artists, here and abroad. Four of them, Frank Brangwyn, William deLeftwich Dodge, Dean Cornwell, and Norman Rockwell were the hardest working professionals of my acquaintance. Because of his own sustained stamina, his dedicated labors expended both in teaching and personal work in a variety of mediums, I dare to hope that my former pupil, Foster Caddell, will attain comparative status with this distinguished foursome.

PETER HELCK, N.A.

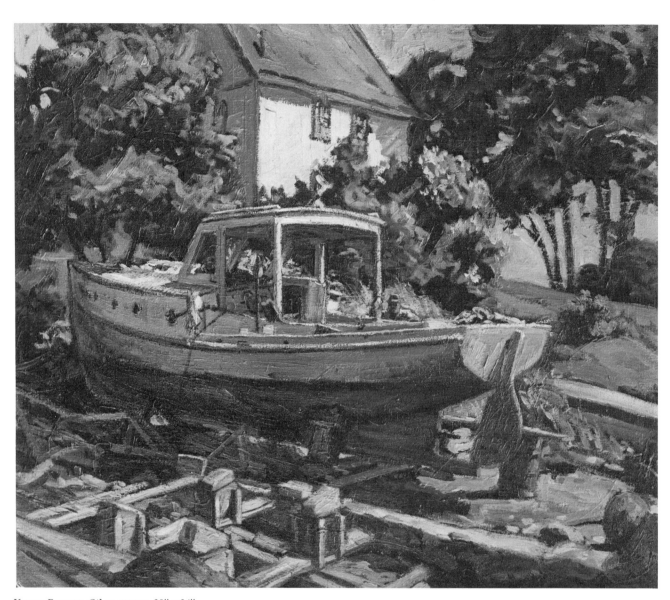

Up for Repairs. *Oil on canvas, 20″ x 24″.*

Preface

This book is written with the concept that whatever your level of painting, you would like to be able to paint better. I believe that someday, somewhere, you will be standing in front of a painting and it may not be going as well as you like. Only the knowledge you have been able to accumulate is going to help you realize a successful painting. I have learned a great deal in teaching many students over the years. My main observation is that they all tend to make the same mistakes. These I want to go over with you, so you will know when you make them yourself and learn how to go about correcting them.

Do not expect to understand or digest the book all at once, for a person has to learn certain principles before he can fully comprehend more advanced information. I tell my students it is going to take them a year to learn to see and think as an artist. Art is a tough master—it gives you back only that which you give to it. I realize that many students can paint just a few hours a week. If this is your case, then be patient with the results. In my teaching, the only thing I am impatient with is student impatience—wanting to produce a good painting before you have accumulated enough knowledge to do so. Keep at it, and each time you paint you will gain a little knowledge that you can incorporate into your next canvas. The greatest asset a student can have is the *desire* to paint—90% of art is dedication and practice, talent only makes it easier. Michelangelo is credited with saying, "If people knew how hard I have had to work to gain my mastery, it would not seem wonderful at all." Just remember: you must equate what you want from your art with what you are willing to give to it.

Painting is really a process of analyzing and synthesizing. The first task is to learn how to see and understand, then to learn the techniques of putting this down in paint. It seems to me that today too much emphasis is placed on expressing yourself and not enough on the technical ability to do the expressing. Personally, I love music, but faced with an instrument I cannot play well, no matter how sincerely and deeply I might feel, not too much of value will be forthcoming.

One word of caution! A person should not desire to learn to paint just one type of subject any more than he should learn to play only one type of music. I often have prospective students claim they can paint one thing well but not another. This is an erroneous idea—it is just that their lack of ability is more conspicuous in some subjects than others. Your training should be broad in scope, encompassing many different kinds of subjects. I firmly believe that until a student can paint a fairly good still life, he is unable to cope with the other types of painting such as landscapes and portraits. If you have good training in still life painting, an area where the subject is fixed and stable, you can learn how to design your canvas properly, draw any shape, analyze values, and mix any color. This is called learning the "vocabulary" of painting. With these principles going for you, you are ready to tackle the great outdoors.

Now, what makes painting outdoors so different? First of all, in the studio—at least in your own studio, not in a classroom—you would set up your subject exactly the way you wanted it, and your interpretation would be rather literal. Outdoors, you are lucky to find a subject that is 75% ideal. This is where your creativity comes in. Many times the composition has to be redesigned—enhancing and improving it here, leaving items out there. I always tell my students, "If you can not make it more artistic than a camera would, you might just as well use one!"

The only rule I stick to in changing things in my painting is that the scene *could* have happened my way—I do not distort or change beyond the realm of possibility. A good landscape painter must be a naturalist, for if you are going to change things, the painting should be convincing. It should look as though the scene actually was or could be the way you have painted it. I am constantly reminding my students, "If you are going to be a liar—be a good one!"

One point I want to stress right here, because it is so important: you must see the finished picture in your mind's eye and know just how you are going to achieve it in order to make a successful painting. I realize most students cannot do this—that is why they are students. Making a painting is like planning a trip. You have to know exactly *where* you are going and every road and route you must take to get there. It must all be very clear in your mind, but that only comes with knowledge and experience. Amateurs paint like a person who gets in a car and tries this road or that, hoping it will be the right one. They do not seem to realize that every stroke on a painting either helps it or hurts it. So many students say, "Oh, I'm just getting something on there," when I notice them painting the wrong color or value. "Something" is not what you want. You should lay it in as thoughtfully as you can from the first.

So, as I have said, to become a good painter, you need the desire, the talent, the practice—and the *training*. Very few painters, no matter how much talent, desire, or practice they had, would have made it without help. Life is too short to learn by trial and error. I was fortunate in having wonderful teachers who did much to smooth the bumpy road that lay ahead. This is what I sincerely hope to do for you, and, if I do, the time spent writing instead of painting shall not have been in vain.

One comment you often hear about art instruction is the fact that teachers have too great an influence on their students' way of working. Do not worry about this. If a teacher does not have an influence on a student, the student has not learned much. The important thing is to find a teacher whose work you admire—to stand in front of one of his paintings and say, "I wish I had painted that!" Then soak up everything he has to say like a sponge. I myself had three, strong, individualistic men as teachers at different

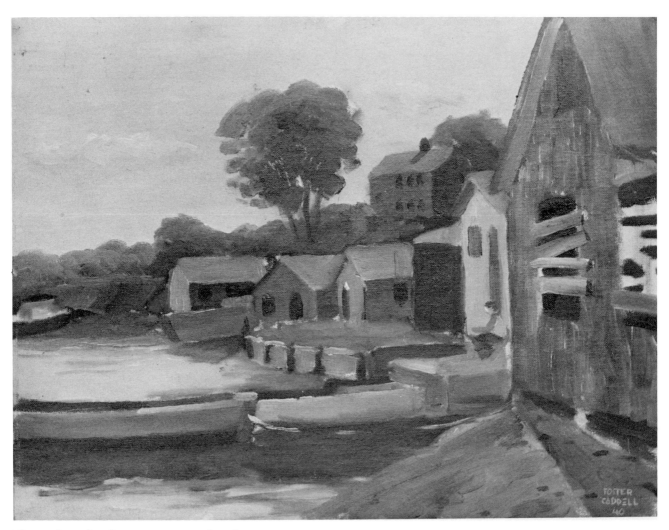

This is a photo of my first painting in an outdoor class.

times in my own development. While I studied with them, my work did resemble theirs, for I greatly admired their approach—otherwise I never would have studied with them. This is as it should be and has been all down through the centuries. After accumulating as much knowledge as I could, I developed my own personal style—hopefully including the best of all they had to offer. I mention this because I feel the classroom is not the place to worry about preserving your individuality. It is a place to gather knowledge; if you really have any individuality, it will come out later.

To encourage you in your efforts, I want to show you the first painting I ever did in an outdoor class. My teacher at this time was G. Gordon Harris, a prolific and rapid painter, who had us go to a different location each Saturday morning and complete a 12″ x 16″ canvas on the spot. Believe me, there have been thousands of hours of "blood, sweat, and tears" from that point to this!

THE MILL COTTAGE. *Oil on canvas, 12″ x 16″.*

Introduction

I feel it is appropriate at this point to go into a bit of detail about the structure of this book. On the following pages, I have arranged sets of paintings that we shall call "keys." Each key occupies two pages—the left side showing a rough sketch which incorporates problems an amateur runs into when painting a landscape, and the right side showing a finished painting which demonstrates the solutions to these problems.

I realize that not all of you will make all the mistakes I show on the problem side of these keys. It has been hard to know just how far to go "wrong" in each exercise, and, depending upon the degree of ability of each individual reader, this may at times seem under- or overstated. If you are part of the way along toward recognizing and solving some of these problems, be thankful—and keep working to overcome the more sophisticated ones.

In each key I have tried to help you by not only bringing out one main point, but also by introducing you to other mistakes an amateur could make painting the same subject. Because I have had my classes out at most of these locations, the problems I point out are not figments of my imagination but are actually based on fact. I have seen so many students make these same mistakes.

On the problem side, I have not attempted to give you anything other than a sketch, or study, sufficient to bring out certain points. I have tried to incorporate *all* the possible mistakes that the amateur could make. I even used poor, stubby brushes in executing these "problems," be-

cause I find most students are not sufficiently aware of the importance of good tools. Throughout the solutions, see if you can recognize repeated evidence of the most important principles, such as grouping your lights and darks into interesting patterns and designs, using color and values to achieve atmospheric perspective, and diminishing detail to create distance in a painting. By having these two reproductions side by side, you will begin to see and understand just what makes the handling of a subject good or bad. I have found one of the fundamentals of instruction is teaching students to recognize the possible pitfalls in a subject so they can avoid them.

Because of the logistics of binding a book, all the color pages are grouped together in a section called Color. Here you will find that the first nine keys deal primarily with color problems and the remaining six, while also dealing with color, could have appeared in other sections had these circumstances not existed. Most of the reproductions are in black and white, and, to some of you who are used to seeing paintings in full color, this may seem a limiting factor. However, viewing a painting in black and white can be a very good test of it, because with the color eliminated, we can judge if the value structure of the painting is sound. As you study the keys in this book, you will notice the amount of importance I place on drawing and value; I hope the black and white reproduction of these paintings will help you to realize that *value* really is more important than *color*.

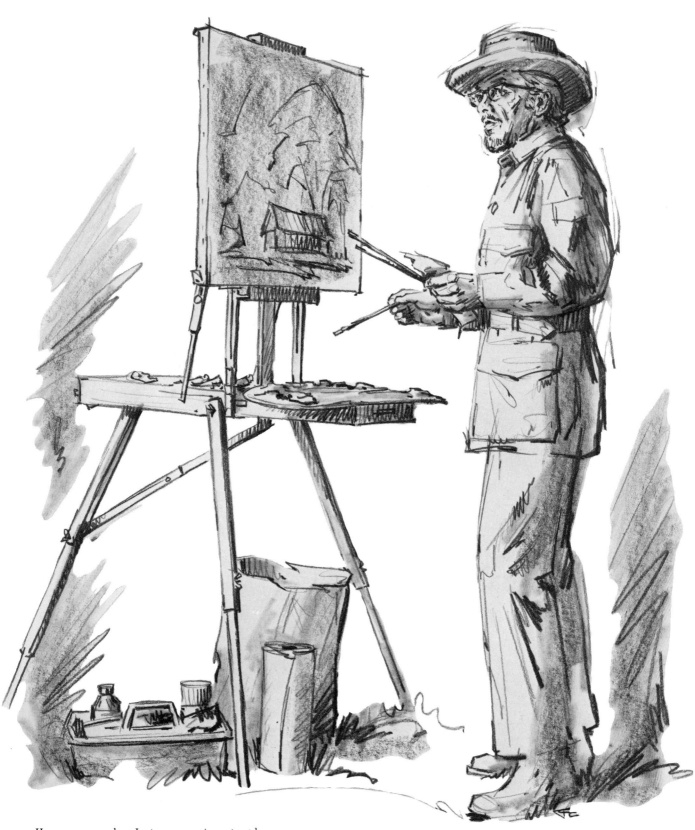

Here you can see how I set up my equipment outdoors.

Materials

Not enough emphasis is placed on the importance of good materials and equipment. Only a very good artist can work with poor materials and usually he will not tolerate it. I worked in the jungles with diluted fountain pen ink and water from a canteen, but I sure wished that I had had better supplies available. The conditions that so many students work under make it almost impossible to produce a good painting. There are enough problems to deal with in making a painting; you should make sure you do not also have to struggle with your materials or equipment.

Brushes. I use good quality bristle brushes. I prefer the *flats* because they have the longest hairs and a greater flexibility to release the paint. Brushes should always be cleaned properly and this I do right out on location at the end of a day's painting.

Surfaces. I work on both a white canvas and a toned ground, but toned canvas must be prepared weeks in advance, so for teaching purposes I stick to normal bare white canvas.

Easels. The only easel that I can unqualifiedly recommend is the combination French Sketch Box. I purchased one of the first models that was imported into this country after World War II and it has served me well over the years. Actually it is so well conceived that there has been very little done to change its basic design since that time. If your art supplier does not have it, I suggest you write to M. Grumbacher, 460 West 34th St., New York, N.Y. 10001. They are the only importing agents. In the sketch opposite, you can see me working at mine. These easels are not only compact and handy, but they also do not blow over in the wind (a very important factor). If it is windy, I usually find a stone nearby which I place on the flat area of the box behind the canvas.

Now one thing to remember in painting outdoors—try *never* to have the direct sunlight on your canvas. If you mix colors with the sun shining on your canvas you will think you have bright, beautiful color, but when you take your painting indoors it will go "dead." This is because so much of your brilliance came from the sunshine on your work. To keep the sun off your canvas you often face the sun and should shield your eyes with a broad-brimmed hat.

Palette. Because of my flamboyant use of colors and pigment, I have found the regular palette that comes with the French Box a bit restrictive in size. So I use a larger palette (shown in my sketch on page 20); this palette unfortunately has to be carried separately.

You should always lay out a complete palette of colors. It is very hard to get new students to do so. I realize that their reluctance is basically an economy measure, but this kind of thinking can become a vicious cycle. For example, when starting your painting, you might lay out a certain color on your palette. You might paint all morning and not

use that color—probably due to inexperience. The next time you lay out your palette, you might not include that color because you do not want to "waste" it again. Of course, if a color is not available, then you surely will not learn to use it. This is why I recommend that you lay out a complete palette every time you paint.

It is equally important to lay your palette out in exactly the same way every time you paint. There is no right or wrong way of doing this, and if one of my students has a way of laying out his colors that is different from mine, I never insist that he change. All I demand is that you have an organized system and stick to it.

Colors. There are actually only three colors—red, yellow, and blue. All the rest are luxuries. There are many ideas and philosophies as to the amount of colors you should use on your palette. Some artists work with a very limited palette, but the paint manufacturers will provide you with an almost unlimited assortment for you to purchase. Sooner or later you will make your own decision as to what colors you feel are necessary and important. My approach is midway. I want every color that is going to help me, yet none that I feel are unnecessary. The basic requisites are a warm and cool of each color. The table on page 23 lists the colors that I use and gives you a short description of each.

Black is a color I do not recommend for students, even though some artists use it with tasteful skill; students tend to use black every time they want to darken a color, the same way they use white to lighten it. For white I prefer to use the combination mixture containing titanium which is sold under various brand names such as Superba or Permalba. Flesh color can be used in paintings other than portraits. When I want to dilute a green and mute it, I use flesh instead of white. I also find flesh extremely useful in skies.

I love the feel and texture of creamy paint and hardly ever use a medium. I prefer soft, flowing paint that is a compromise in texture between soft butter and heavy cream. There are many students who are constantly trying to remove the skin from globs of paint they placed on their palette days ago, not realizing that the chemical action which is supposed to take place *on the canvas* is already taking place *on the palette.* I hear some students discussing at great lengths their methods of preserving paint, even to the extent of placing the palette in the freezer. I often wish there would be as great an interest in the methods of *using* it.

Other Materials. I always work with a cloth or paper towel in my left hand, constantly wiping and cleaning my brush between mixtures. Below me, on the ground, I keep a roll of paper towels (which I like better than rags), and most important, a paper bag to throw my trash and painty paper towels into. *Always* leave the areas you work in with no evidence of human contamination. Also on the ground I

THE PATRIARCH. *Oil on canvas, 20″ x 16″. Courtesy of Mrs. Foster Caddell.*

keep the plastic tray containing my retouch varnish, which I use at the beginning of each painting session to re-establish the wet-strength value of my colors; bug spray; and paint thinner for cleaning my brushes.

I am one painter who makes most of my paintings right on the spot. Not all painters do this, but I like being in first-hand communication with nature, which provides patterns and colors that I would never dream of in the studio. There are some very successful painters who do most of their work in their studio. I could make a painting this way and the viewer would probably never know the difference, but I just feel that I would revert to standard clichés for solutions to problems and not get the visual stimulus that I find out on location.

Now the one danger in painting from nature is that some people feel they must copy nature rather than interpret it. I find this inclination prevalent in my students after they have been in the studio all winter, working rather literally. Nature requires a great deal of selective organization: choose what is good, eliminate the superfluous, and arrange the important facts into a strong, dramatic, and simple composition. As Aristotle said, "Art has a double function: it must both imitate and transcend nature."

One last thought from years of experience: When I first started to paint, I would often find myself driving for miles to find something that would justify my time and effort. The longer I paint, the more often I find subjects close at hand. I have, and you will, come to the mature realization that, as a song of some years back said, "It ain't what you do, it's how that you do it!"

Color Group	Tube Color	Comments
Red	Alizarin crimson	The coldest of reds.
	Cadmium red deep	A middle red, neither warm nor cold.
	Cadmium red light	The warmest and brightest red.
Yellow	Cadmium yellow deep	The warmest yellow.
	Cadmium yellow pale	The lightest and coolest with no red in it.
	Naples yellow	A very handy, light earth yellow.
Green	Permanent green light	A useful yellow green.
	Viridian	The coolest green, almost a blue when diluted with white.
Blue	Cerulean blue	The warmest blue, which makes wonderful grays when mixed with cadmium red light.
	French ultramarine blue	The deepest and reddest blue.
Earth colors	Yellow ochre and raw sienna	Practically the same color, but used according to their different values.
	Burnt sienna	A wonderful warm earth.
	Burnt umber	Deeper, with less red than burnt sienna. (I have yet to find a use for raw umber except in staining frames.)
Gray	Payne's gray	A mixture of French ultramarine blue and black, which is often better than black alone.

Here are the colors I use in my painting.

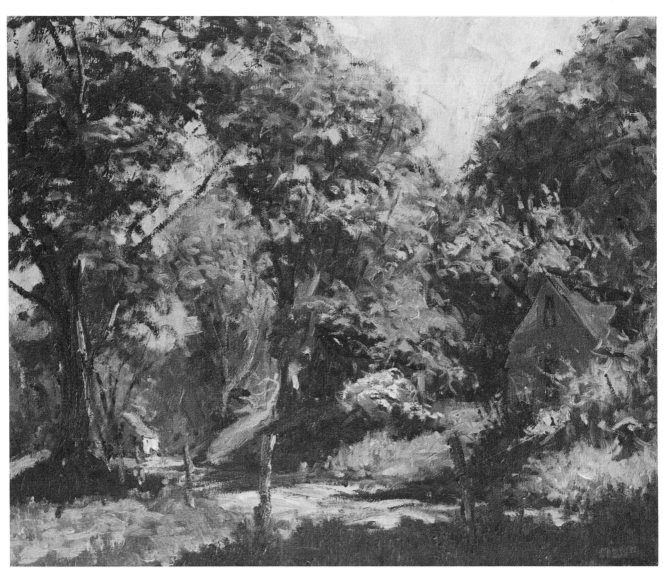

THE PATTERNS OF SPRING. *Oil on canvas, 16″ x 20″.*

Procedures

In this series of reproductions, I want to show you how I actually construct a painting. This painting, which is also reproduced in color on page 125, was actually done as a class demonstration over five successive mornings. I took these photos each day, for the express purpose of showing you this step-by-step procedure.

I *cannot* overemphasize the importance of the first step—designing the canvas. Do not be fooled by its seemingly simple and sketchy appearance. More paintings are spoiled in the first half hour of work because the amateur is so anxious to paint he does not take time to design the structure of his painting properly. The decisions you make on composition and design at this point will govern how successful your canvas is when completed. Your drawing might be considered the skeletal framework of your painting.

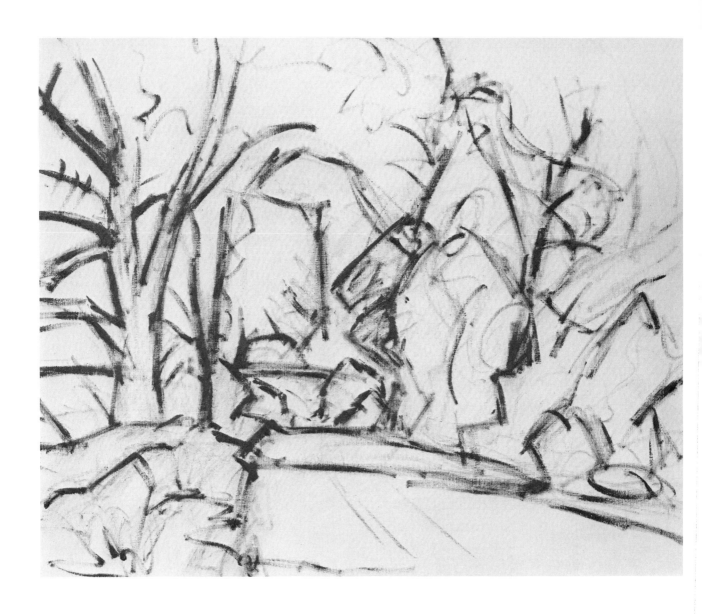

DESIGNING THE CANVAS

In my classes, I stress over and over the importance of being able to draw well. However, a few words of caution about drawing. The fact that you can draw well does not mean you have to draw in detail. Many students draw this stage out so well that they are afraid to get in and paint for fear of losing their careful drawing.

My first lines on the canvas are with charcoal because this is so easily wiped off and changed. Even in this stage, I am planning my composition with consideration for patterns of lights and darks. When I think I am on the right track, I dust down my charcoal lightly (you can see evidence of this in the photo) and reconstruct the canvas with an earth color, such as yellow ochre. This is not merely an automatic repeat of the charcoal line; it is actually a reconsideration of my initial decisions to see if they are as sound as I thought they were, and an adjustment of passages where I deem it necessary.

If all this has been done correctly, the result should be a well-conceived and designed composition.

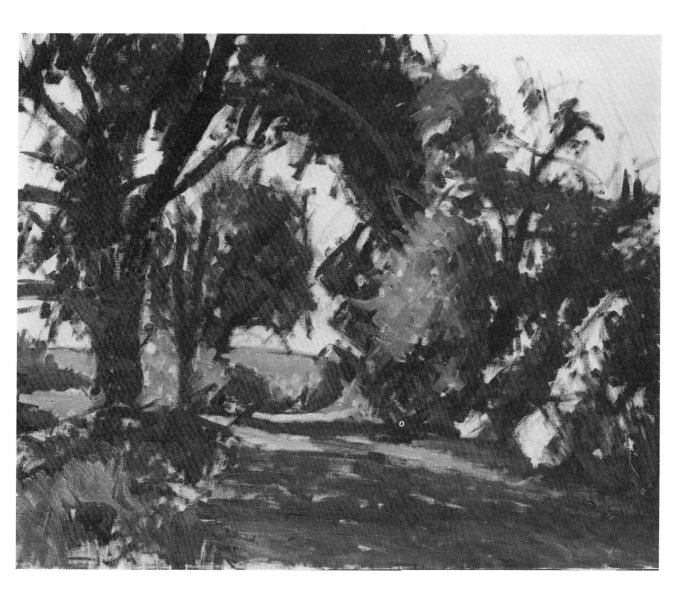

LAYING IN TONAL VALUES

Now we are ready to start putting paint on. The object of this step is to cover the canvas with a big pattern of values and color. A very common mistake my students make is to begin to paint the lights first. Here, for example, the student would start to get the sky in first. It is very difficult to paint lights correctly on a white canvas because there are not any other values to relate and compare them to. Technically, we cannot paint lights lighter than the priming of the canvas, but we make passages *look* lighter by their relationship to middle values and darks. The first objective in starting a painting is to establish the complete range of values—to know where the lightest lights and darkest darks are, because all the other values are gradations in between. Since the bare canvas serves as our light end of the scale, we should first establish the darkest darks. Then we can begin the process of comparative analysis.

First, I attack the large tree trunk on the left. Unspecific

colors like these are usually a combination of the primary colors; I use French ultramarine blue, alizarin crimson, and raw sienna. These colors and values are repeated in the stone wall under the tree and in the portion of the tree trunk showing on the right. Then I turn to the dark passages of foliage—at this point there is no attempt to paint trees or leaves, since I am only going after the large pattern and design. Next, I turn to the middle values. In those passages that will be lights in the foliage I now put a darker underpainting. This will show through a bit when I overpaint it. I introduce blue atmosphere into the trees at the far end of the road and into the hills in the distance. The shadow pattern of the road is laid in now; this I initially paint in cool colors because shadows are illuminated by the cool sky. While the shadow area is still wet, I paint into it beautiful variations of warms, without destroying the coolness.

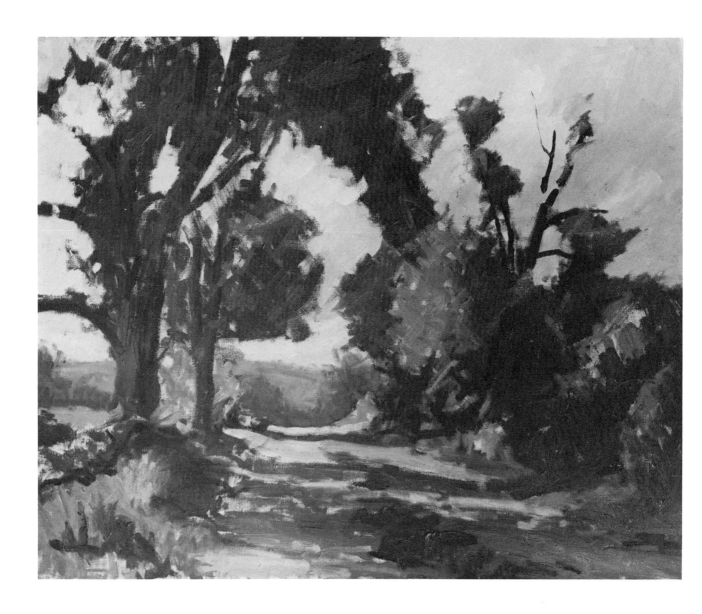

INDICATING THE LIGHTS

When the darks in the trees are dry, I can begin to paint the sky; now I can better judge the color and value of the lights by relating them to the dark passages. A sky like this is really a pleasing abstract design that also adheres to those principles which distinguish a good sky. Notice how the sky is lighter on the left side—indicating the source of light—and how it is also lighter down at the horizon. Observe, also, how loosely the sky is laid in and how the edges of trees are painted over. A student would usually try to save these drawing lines, but actually they should be freely overlapped. This is one of those skies in which I use flesh color; while the sky is still wet, I paint a warm flesh into it. At this point you should be able to see what your finished painting will look like. If you have not reached a major statement by now, you never will.

This might be a good time to elaborate on the importance of using retouch varnish. The purpose of this is to re-establish the wet strength of the paint so, as you continue, you have a more accurate comparison to the passages already painted. Paint dries a slightly different value than when it is wet and I have seen students repaint passages thinking they were not dark enough, when, actually, all they needed was spraying with retouch varnish before re-working. Be sure you *do not* use full strength Damar varnish at this point for it will seal in your paint layer and prevent the succeeding applications of paint from forming an integrating bond with previous ones. It is most unsound to use full strength varnish too soon as varnish dries fast and paint very slowly.

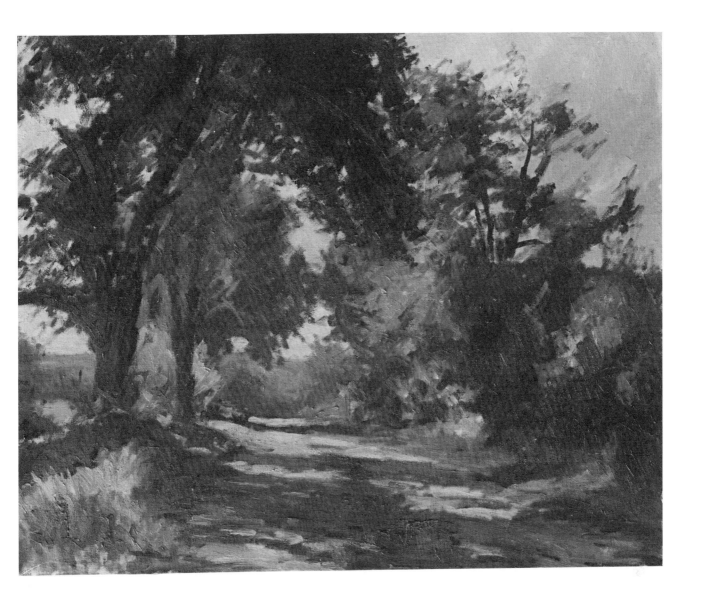

PULLING IT TOGETHER

Students often flounder when trying to paint both sky and trees at the same time; they accidentally pull the dark paint of the trees into the light sky. After years of painting, you get to know just what should be done when. There are some passages that are best done wet-in-wet, and there are others that are better done on a dry canvas. In this case, now that the sky is dry, I can get back to re-establishing the trees.

There are two basic patterns in any painting: one formed by those areas hit by light and one formed by those areas cast in shadow. When you get to the refinement stage of the painting, you must be careful that you do not lose or destroy these big, simple patterns as you overpaint. Notice how in this demonstration the detail or refinement is only gradually introduced. Students have a great tendency to go right in, complete one section of their canvas, and then go on to another. I often see half the painting almost done and rest of the canvas hardly touched. This is wrong! The

painting must all be brought along together, as shown above.

Here I develop the design and pattern of the foliage. In Step 2 all I wanted was a rough generalization; now I want to convey the more subtle nuances. A green summer painting is rather difficult. One of my keys is devoted to the principle of taking advantage of every opportunity of introducing warm colors into the greens. On the right side of the road, there are wild grape vines growing in and over the bushes and trees—this provided subtle purple variations. This painting was made in late summer and here and there the leaves were beginning to turn color; the grasses contained a bit of brown—all these items I exploited and wove into my tapestry of color. Notice also how the trees on the right are becoming a delightful abstract design in comparison to the well-defined trees on the left. These refinements are the esthetic ingredients that you must learn to understand and use in your own painting.

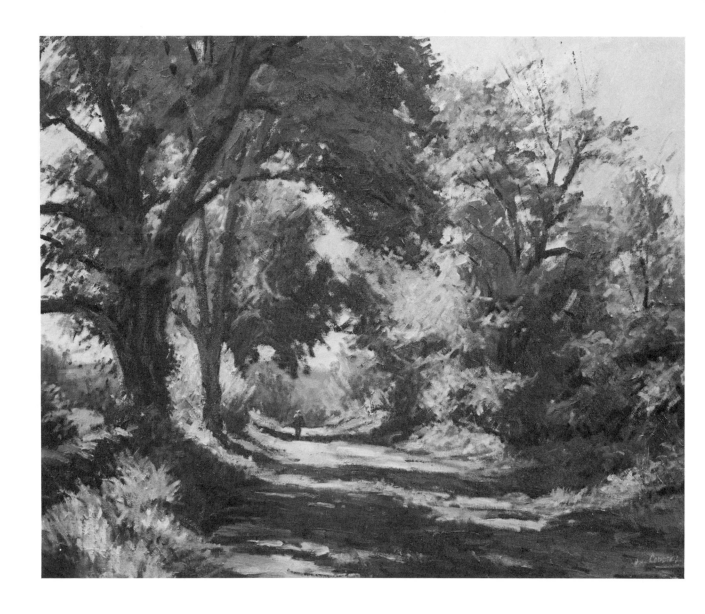

THE FINISHING TOUCHES

This is the point where you bring the painting to a conclusion. How far you go in this direction is a matter of opinion. Some painters go to extreme detail, others leave their work very loose. Neither way is either right or wrong or good or bad. Sooner or later, you will have to decide what degree of finish or refinement *you* consider right. My philosophy is to train the student to be able to achieve a great deal of refinement, so the point he stops at along the way will be controlled and intentional.

The details that I put on at this stage I often find students putting on in the beginning. They are concerned with clapboards on a house before they have a solid structure with sunlight on one side and shadow on the other. I am constantly reminding them, "Be sure you have a good solid cake before you start putting the frosting on it." As I get closer to finishing the painting, the strokes of my brush usually get smaller. Even so, I try to maintain a certain freedom and spontaneity in my strokes.

Now the highest lights are placed on the foliage. The stone wall on the left and grasses in front of it are more sensitively defined. Notice the detail of the light pattern coming out from behind the big tree on the left and crossing the road. We can sense the different textures where it runs over road and grass. The structures of the trees are given more attention. Notice the poison ivy vine climbing up the large trunk. It is at this point that I usually add a figure if I consider it helpful. Here the very size of the man helps create an illusion of distance and space.

There is an old saying that it takes two people to make a painting: one to paint it and the other to hit the painter on the head when it is time to stop. When you reach the point where you cannot see how and where to add a helpful stroke that will improve the painting—stop! You have reached the extent of your intellectual capabilities of dealing with the problem. Remember to turn to the color reproduction of this painting on page 125.

PASTEL STUDY OF AN ELM TREE. *Pastel on paper.*

Spring. *Casein, 15" x 13".*

Illustration

A point I would like to touch on here is that I freely acknowledge my background as an illustrator. There is a contemptuous attitude among certain people toward any artist that has had anything to do with the "commercial world," but they fail to realize that some of the great painters of history, such as Michelangelo, Rembrandt, and Rubens, might have been considered "commercial" artists. To be a commercial illustrator one has to be good enough so someone agrees to pay you for a painting before it is made. I acknowledge that there is a great deal of poor-quality commercial art, but there also is a great deal of shabby easel painting. When I speak of illustration, I am thinking of the "greats" such as Howard Pyle, Harvey Dunn, N. C. Wyeth, and the succeeding generation such as Peter Helck, Dean Cornwell, Harold Von Schmidt, and Robert Fawcett to name just a few. I would be proud to have my name associated with such a great assemblage. My contention is that good painting is good painting regardless of whether it is commercial or not.

I would like to show several illustrations I have done that contain the same principles as I will talk about in the Keys.

ILLUSTRATION 33

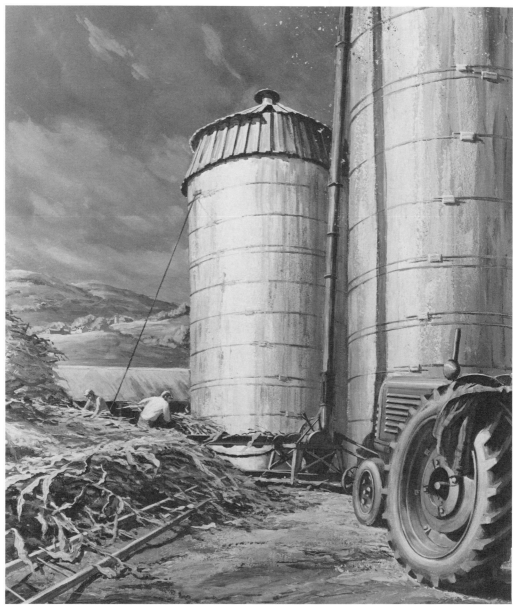

FILLING THE SILO. *Oil on canvas, 16″ x 14″.*

DIRECTIONAL LINES

First of all, notice how the directional lines in the composition carry the viewer's eye into the central theme—that of the men feeding the corn stalks into the cutter, or blower. If this were in color, you would see that this machine is also *red* which further commands attention. The value of the sky has been reduced so that our eye stays on the bright passages of the silo. There is greater detail in the foreground than there is in the distant hills. Much thought has been given to designing this picture so lights and darks effectively register against each other.

The basis for this painting was a sketch I made one day out at a local farm where this operation was taking place— how else would I have known to include such authentic detail as the flakes of silage drifting down from the top of the silo where the breeze causes some of them to go astray.

Notice the diversification of handling—the tractor on the right is quite defined, the clouds in the sky feel soft, the pile of corn stalks have enough definition here and there so any farmer would know what they are, and in the silo itself we can sense the rough weathered boards and the hard metallic dome.

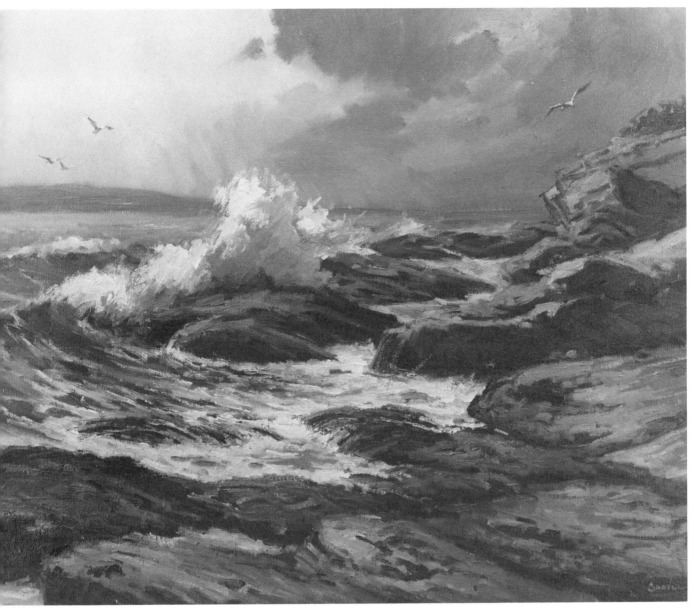

Surf Off Beavertail. *Oil on canvas, 24″ x 30″.*

TONAL INTEREST

To demonstrate that the same principles as I will be discussing in the Keys are incorporated in other types of painting, I would like to show you this painting of the surf that I did as a demonstration for my class.

First of all, the tonal climax is at the center of interest. The lightest lights and darkest darks come into juxtaposition where the wave crashes against the rocks. The sky is lighter on the side of the source of light, but notice, it is not as light as the lights on the surf. Also, see how I designed the sky so a darker value becomes a foil behind the lights of

the foaming water. Observe how the directional lines carry the viewer's eye into the center of interest from almost every part of the painting. Even the sea gulls are strategically placed—the ones on the left are flying into the center of interest, and the one on the right is tilted so the angle of its wings also points to the crashing wave.

As a well-rounded artist, you should learn to paint everything. You will find that the major basic concepts of approaching a canvas apply to almost all subject matter.

ILLUSTRATION 35

SCHOOL'S OUT! *Oil on canvas, 20″ x 24″.*

Drawing

You are going to spend many hours applying paint to your canvas, but the end result can be disappointing if the initial drawing is not correct. Designing is drawing, for not only should things be drawn well, they should be placed correctly within the confines of whatever canvas you are using, be it 8″ x 10″ or 30″ x 40″. More paintings are spoiled in the first few minutes by the amateur who is so anxious to paint that he does not take the time to scale and compose his canvas correctly. With drawings, watercolors, and pastels, which ultimately have a mat around them, the composition can be cropped a bit here and there, but with an oil painting it is different—the decisions you make initially you are usually stuck with.

You do not have to draw in great detail at the composing stage—all you really need is a careful consideration of where the big areas are going, the detailed drawing is then gradually incorporated into the painting in each successive stage of its development. (Refer to pages 26–30 for a step-by-step demonstration of how I make a painting.) I find many times that because I stress the importance of drawing, the student will draw things in with far too much detail in the initial stages of a canvas. Then they are afraid to get in and paint for fear of losing the drawing they have worked so hard to produce. Making a painting is not like drawing a map and coloring it in.

Remember: the first step toward becoming a professional is being able to determine *what* should be done *when*.

1. Redesign Your Subject Whenever Necessary

PROBLEM

Nature doesn't always design things in a way that they fit and balance well within the dimensions of your canvas. In fact, you're doing well to find subjects that are 75% ideal—this is where your taste and selection can take over and improve on them. There are some basic rules for composition, but a great deal is just "felt": the picture must "feel" balanced and not be too heavy on any one side. We must adjust unfortunate alignments and try to introduce a pleasing design of lights and darks. Unless you have to make a faithful rendition of the subject, do not hesitate to even move objects around, for your main concern is to come up with a good painting rather than a *record* of the place.

This painting should have been given a bit more creative redesigning as you can see. It is too heavy on the right side because both the large house and the big tree are on this same side. The roof line of the barn in the middle of the picture happened to coincide with the house at an unfortunate point, giving us a repetitious design between the barn and the lean-to shed attached to the house. The distant tree line terminates at the barn roof on the left and the road repeats this same thrust to the left below; both lines sweep us out of the picture. I'd like to make a point here about chimneys because most students don't think enough about how they are constructed. Chimneys usually straddle the ridge pole—they do not sit on one side of it.

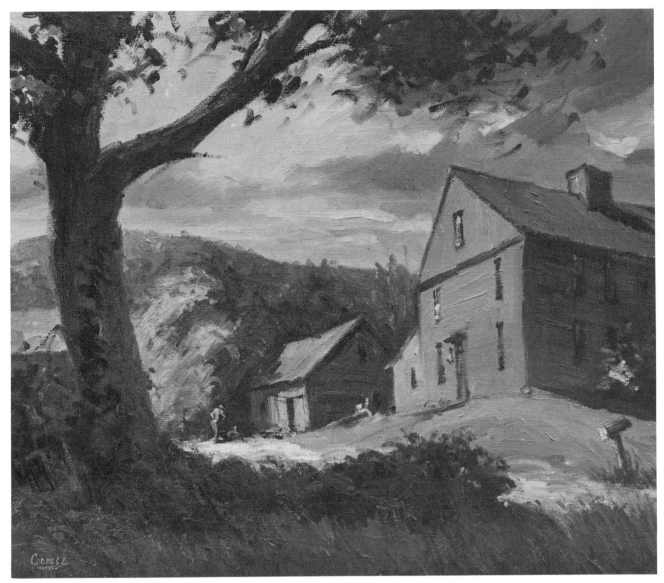

SUMMER IN RIXTOWN. *Oil on canvas, 20″ x 24″.*

SOLUTION

By taking artistic liberty and redesigning this composition, we have taken the subject out of the realm of the ordinary. The big tree was moved to the left side and given a bit of rhythmical curve and flair. As a result, our eye now enters the picture in the lower right area by the mailbox. Because I kept the foreground entirely in shadow we sweep up the tree and the limb carries us across the top, where we come down the corner of the big house and back over to the center of interest. Here I introduced a figure working by the barn. The design forms a veritable spiral that keeps our eye continually going "into" the picture and never leaving it. I moved the barn over to avoid the unfortunate alignment with the house and accented the center of interest with the dark tree shadow falling on its roof. This gives me a tonal climax (discussed in Key No. 16) to play the figure against. I changed the road to dirt and splashed sunlight over it; by introducing a bush in the foreground, I broke the parallel lines formed by the road. The last improvements I made in the design of this composition are the inclusion of a hill in the background, which gives us a line flowing into the center of interest, and the lights and darks in the sky, which now form an interesting counterthrust. When you make a painting, it should be the most artistic rendition you can possibly come up with. Give more thought to redesigning where necessary and see if you can't achieve a much more artistic solution.

2. Look for the Dramatic Possibilities of an Unusual Vantage Point

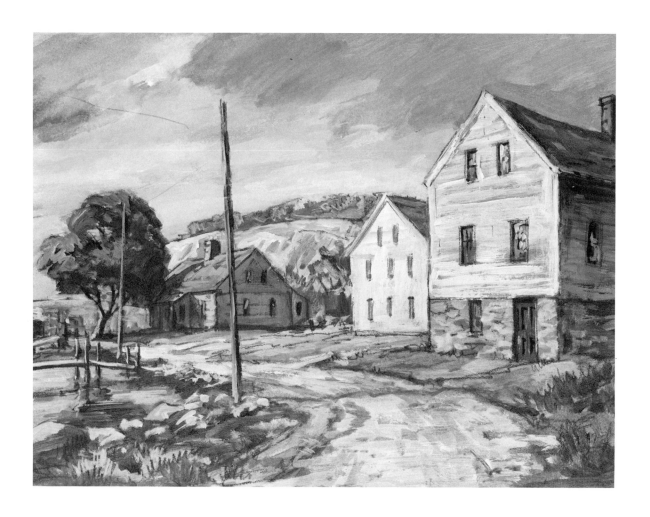

PROBLEM

When painting in a new locale many artists, in their haste to get started, settle too quickly on the easy, obvious solution to a composition. This habit, if continued, will limit the possibilities that exist for making much more interesting paintings. The waterfront has always held great interest for artists and we in New England have many little villages whose buildings go back 100 years and more. My studio is near Mystic, Connecticut, and one day I was down there looking for material for a painting. I made several rough sketches around the waterfront, and this is from one I made on a road that ran along the water's edge. With a bit of redesigning and the right use of color, it could have become a reasonable painting, but still rather ordinary, like many you have seen at exhibitions. The intent of this book is to help you to paint better than average paintings, not ordinary ones, so this chapter deals with looking around for a different vantage point than the one that first presents itself. There was another large rock formation to my right, which is not shown in the painting above, and I climbed it to see if it offered any different possibilities. The painting on the opposite page shows you that it was more than worthwhile and gave me a composition that was no longer ordinary.

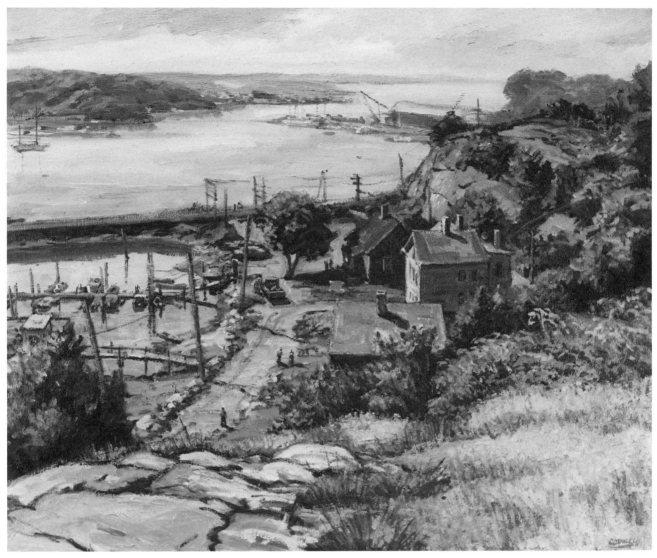

MYSTIC HARBOR. *Oil on canvas, 24″ x 30″. Courtesy of Mr. and Mrs. David Reier.*

SOLUTION

Here we can see how a locale that first appeared unspectacular proved to be more interesting when viewed from a different vantage point. Now we look down not only on a little waterfront community, but also beyond the railroad tracks to the harbor as it winds out toward Long Island Sound. Notice how five different atmospheric planes exist in this painting, with an appropriate diminishing of color and values. (See Key No. 39.) Also notice that the effect of distance is accomplished by the way I handled detail. The rocks and grass in the foreground are quite detailed, but as we go back in the picture, I suggest detail in each succeeding plane in a softer and less distinct way.

I found it most fascinating looking down on the daily life of this little waterfront community, and I tried to capture this feeling in my painting. At the center of interest we have the local store, and I introduced a spot of color here by having a small, red pickup truck parked at this junction. By using several small figures in the scene, I indicated the human element which is so typical of a spot like this in midsummer. Looking around and climbing the hill proved most worthwhile to me and I hope it serves as a good lesson to you.

3. Include Only One Center of Interest in a Painting

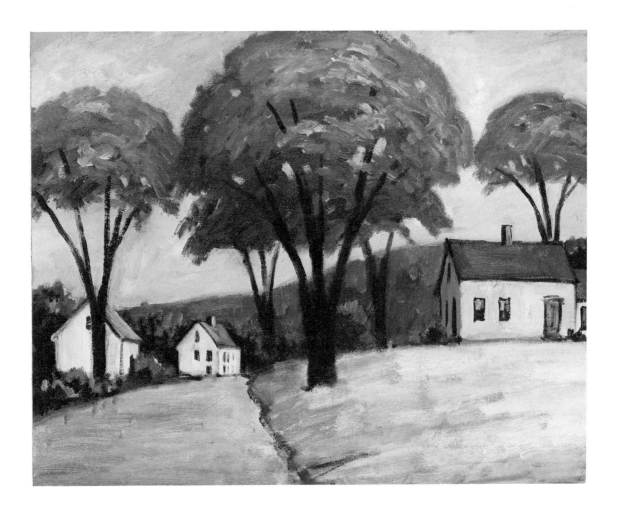

PROBLEM

In another key, we have taken up the problem of how to keep the sky and the landscape from competing with each other, that is, how to give the viewer only *one* center of interest to look at. This problem can also take place in the landscape itself, as shown in the painting above. Many times, more than one area presents itself as a possible main theme or center of interest for your painting. But resist the temptation to put more than one center of interest in your composition. This is a common mistake among amateurs. It is almost like depicting a fork in the road and making each vista equally interesting. If there is more than one center of interest, make more than one painting; feature one and subordinate the other in each instance, but *never*

crowd both into the same canvas. In the painting above, each half could have become an independent and interesting painting. The solution is almost like thinning out new plants in a garden—one must be sacrificed to allow the other to mature and develop. The large foreground tree has unfortunately been placed directly in the center of the composition, and the remaining trees are placed in an uninteresting design. A subsconscious tendency exists in all painters to revert to symmetrical design and repetitious shapes. This happens not only in the trees, but in the way the line of the distant hills repeats the line of the grass and road below.

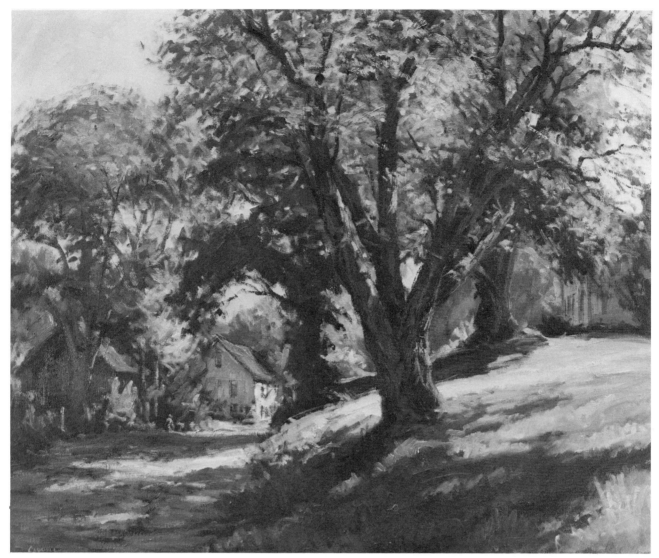

CLARK'S FALLS GRIST MILL. *Oil on canvas, 24" x 30".*

SOLUTION

Here we have practically the same scene and composition, but by shifting our attention to the section on the left, placing the big tree slightly off-center to the right, and playing down the house on the right, we have a much better composition and painting. I often caution my students, "Don't give them too much!" This is just another way of saying, "When in doubt—simplify!"

While we are on this painting, I would like to point out some other important elements for your consideration. This composition is nearly the same as the one on the opposite page—almost half road and half lawn—but notice what I have done here to make it tolerable. I first moved the grass line to the left and made it softer. Then, by choosing a time of day that threw tree shadows over the area, I made the design and pattern of lights and darks more dominant than the design of road and grass. Except for the tree behind the white house on the right, we still have the same placement and design of trees as in the problem painting, but see how with skillful, soft handling, they are now acceptable rather than bothersome. If you can only learn what traits are typical of the amateur artist and gradually eliminate them from your work, you are well on the way to a much more mature and gratifying approach to your efforts of successful landscape painting.

4. Understand and Apply the Rules of Perspective

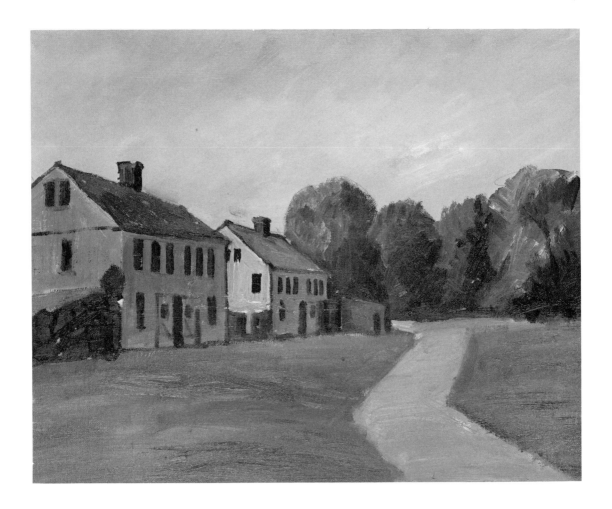

PROBLEM

There are some teachers who tell their students that it is not necessary to draw well in order to paint. With a statement like this, they are either fooling themselves or their students, for, unquestionably, the better you are able to draw, the better you will be able to paint. In this key, I want to show you another example of the mind of the student dominating his ability to see literally. I have found overwhelming evidence supporting this observation in many students' work, yet I have not heard this principle pointed out and stressed by other teachers.

In this key we are dealing with *line*, or the drawing, of some old farm buildings. If you were to walk around them, as you probably would before settling on this vantage point, you would realize that the sides of the buildings (facing the dirt road) are *physically larger* than the ends of the buildings (facing us). However, the sides *look smaller* than the ends because of the angle of perspective. Invariably the student will not draw what he sees, but rather what he knows: he will draw the sides larger because they really are, even though they appear smaller in perspective.

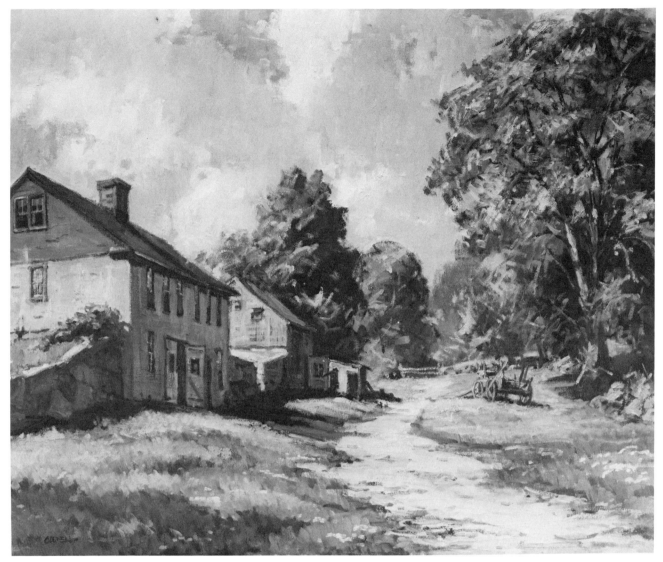

FARM IN ESCOHEAG. *Oil on canvas, 24" x 30". Courtesy of Dr. and Mrs. Christopher C. Glenney.*

SOLUTION

There are two ways to be able to draw well: learn all the rules of perspective and develop exquisite perception. Make good drawing a habit, and then when it *counts* it won't be such a struggle and leave you so frustrated. Here is the way the buildings actually looked. Drawn correctly, they now recede rather than appear turned, as on the opposite page.

Let us consider other favorable factors of this painting. The composition is almost the same in both instances, but here I have borrowed a big elm tree from outside the picture area—see how this balances the weight of the buildings on the left. Now look at the background trees in the center of the painting. Notice how they are not only designed in an interesting way, but that they have three pro-

gressive value stages taking place in them. The grass area in the foreground was a delight to develop, with its various textures, colors, and patterns; observe especially the soft edges to the dirt roadway. With this much area devoted to sky, you have to come up with something interesting. Here we have mostly big cumulus clouds forming an upright pattern high in the sky. In designing a painting, I always look for interesting possibilities, such as the light pattern on the little chicken coop in the center of the painting. There I placed the figure of the farmer carrying food out to the chickens—see how the figure becomes an interesting silhouette against the light building. As a finishing touch, I added the farm wagon.

5. Prevent the Viewer's Eye from Leaving the Picture

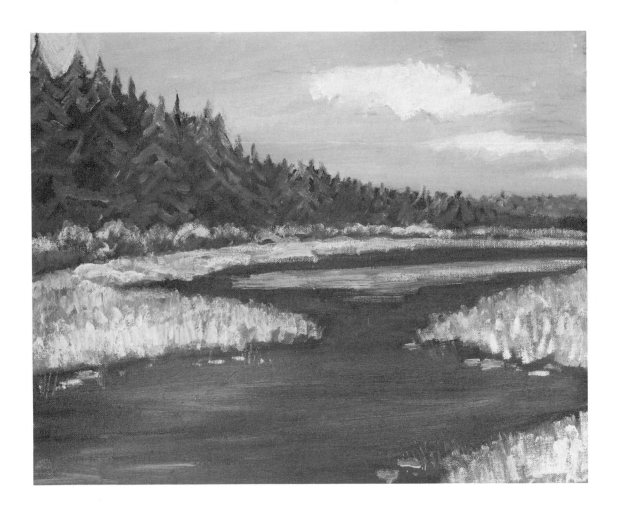

PROBLEM

A principle like this is something that the student does not even think about; in fact, he seldom knows it exists. The professional, on the other hand, is very conscious of this point. In a general exhibition, an artist wants to capture the attention of the viewer and hold it on *his* painting. He wants the viewer to linger long enough to savor and appreciate those passages he has so carefully thought out and rendered.

There are big directional thrusts in the design of a painting such as this one. These are fine so long as they do not carry us right out of the canvas, as they do here. The line of evergreens beyond the marsh is much too regular in its sweep down from the upper left corner to the right side of the painting. The open water repeats this directional thrust from the lower left to the upper right, making an unfortunately symmetrical design. Nature does not always arrange these weeds in an ideal way—it is up to you as an artist to redesign them whenever necessary. Here we can see that the shapes of the grassy areas are quite bad, with both pointed areas coming out at the same place in the composition. The wind ripples in the water area beyond are badly placed and accentuate the thrust out of the canvas. Notice how even the clouds repeat this thrust. Subjects such as this can become fascinating paintings only if they are handled sensitively and well.

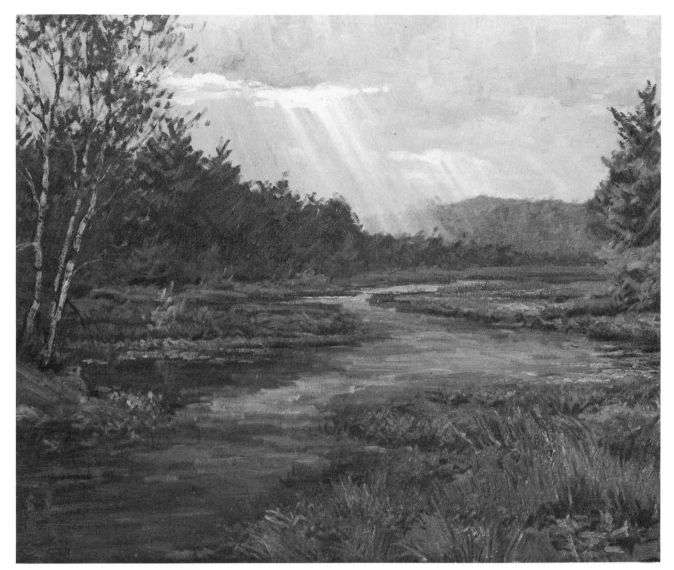

Storm's End. *Oil on canvas, 24" x 30"*.

SOLUTION

When you have a strong directional thrust that sweeps the viewer's eye out of your composition, you should put a "block" there to stop the exit and turn the eye back into the painting. It is such a simple and basic solution, yet if you fail to realize its importance and utilize it, the results are disastrous. Here, I created a block by introducing the tree at the right. Notice that the height of the tree is important also—it is not as tall as the birches in the left foreground, but taller than the pines farther back on the left. Every passage in a painting should have a reason and a purpose.

Let us go over other points that make this a successful painting. The water channel was more thoughtfully designed. The area of weeds in the lower right was enlarged

and developed with greater detail into a tapestry of colors and shapes. The birches and bare peninsula were out of the composition to my left; I moved them into the painting for a better design. Including the birches also keeps the area of fir trees in the middleground. This area of fir trees is now made smaller and the top edge more varied. The distant plane was enlarged in size and its main directional thrust brings the viewer's eye back into the composition to the dramatic sky. I seldom make a painting of a flat, overcast day. The sky, of course, never looked like this while I was painting. It is purely imagined and painted from memory, but I felt it was the necessary crowning touch to take this painting out of the realm of the ordinary.

6. Guide the Viewer's Eye into Your Painting with Directional Lines

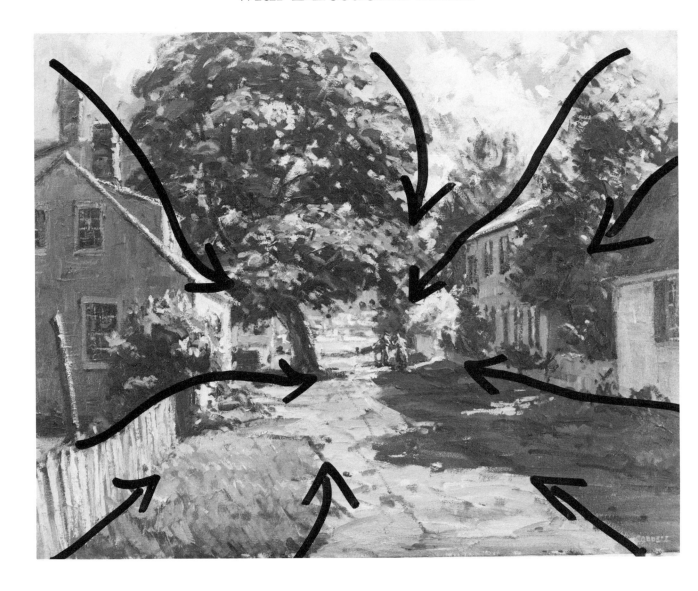

EXAMPLE ONE

Perhaps you have not given this subject much thought, but the professional artist tries to make viewers see what he wants them to see in his painting. In Key No. 5, you saw how I prevent the viewer's eye from leaving the painting—in this key you will see how I guide the observer *into* the center of interest with directional lines of the composition. Sometimes these directional lines are large, sweeping S-curves, and other times they are simply flowing, directional arrows leading in from corners, as you see here. On this side, rather than showing you how *not* to do it, I decided to make a weaker print and superimpose strong di-

rectional arrows right on it so the message would be quite obvious.

The composition presented by nature is not always ideal. You must give a lot of thought to the best vantage point to paint from, but, even then, many times there are changes that have to be made. A distant hill line is reversed, a tree is moved, the composition is changed in order to utilize the principle shown here. As you learn to control your subject matter, rather than having it control you, you will become master of the situation and will be making greater paintings—rather than records of a place.

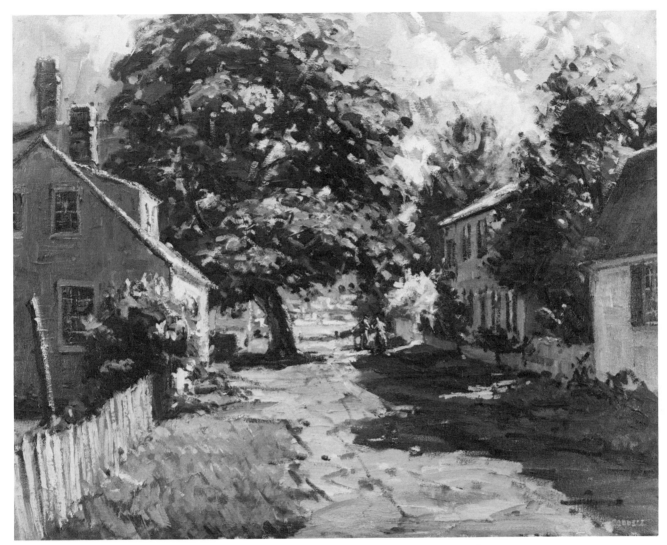

MORNING ON BAY STREET. *Oil on canvas, 20″ x 26″.*

EXAMPLE TWO

Without the benefit of the dark, superimposed arrows, study the above painting and see how your eyes follow these same directional thrusts even in their subtle rendition. I grant you, this particular scene offers an overwhelming opportunity to display this principle. It cannot be so obviously used in many instances, but study other paintings in this book and see how often it is used. Whenever possible, I try to design the composition so that there is a dominant flowing line *into* the center of interest, particularly from the corners.

While we are viewing this painting, let me comment on it further. This subject is typical of the old colonial villages situated along the New England shoreline. They are de-lightful to paint, offering the contrast of stark geometric patterns in the buildings against the softer patterns of the trees and bushes. Notice how casually the picket fence in the lower left corner is handled—few amateurs would dare to be this suggestive. Throughout the painting there is a great deal of thought given to the design pattern of lights and darks—of course the time of day you select to paint has a lot to do with this, as we discuss elsewhere. The burst of light coming from behind the house and falling on the couple in the lane, and the boats anchored in the distant cove give the viewer a delightful center of interest to linger in, once he has followed our guiding directional lines to get there.

7. When in Doubt, Simplify Your Design

PROBLEM

Design in a painting concerns the pattern that the areas of lights and darks create, as well as the shape, size, and placement of the objects themselves. This is something that the amateur is so little aware of. In fact, I would say that an awareness of this factor and its introduction into your work might be the main step in the difficult transition from amateur to professional painting. I am constantly reminding my students that the design created by the play of lights and darks *on* the subject is esthetically more important than the subject itself. When students first start to paint, they are quite happy to make a satisfactory "record" of the subject, but a painting should be much more than that. In the above problem painting we can see the end result of the lack of an organized design. Faced with a subject such as this, the novice is overwhelmed by the thousands of leaves and fails to realize that out of them he must organize a pleasing design. I have kept the basic design of the subject matter much the same as in the solution painting, so we are dealing primarily with the design factor of the lights and darks. Because the student is not aware of this important element, it usually does not exist in his work, as you see here. There are just many, many clumps and bushes, the contrast is flat and uniform, the shapes and spaces are repetitious, and it is all handled in much the same manner. The result is a very monotonous and spotty picture.

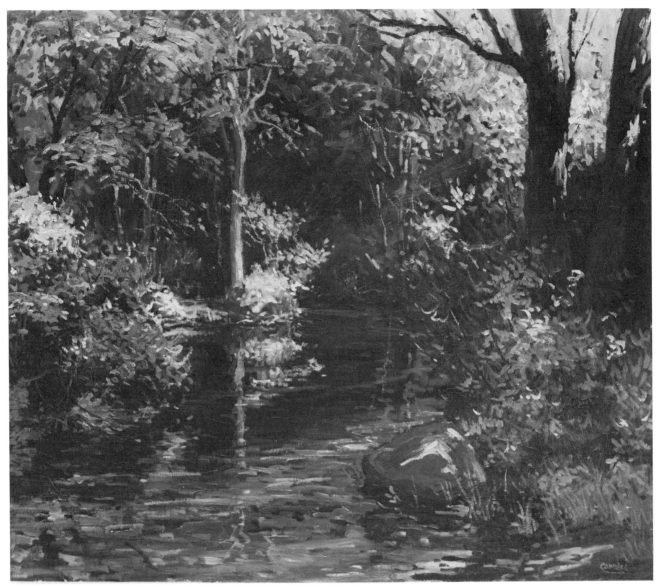

QUIET BROOK. *Oil on canvas, 30″ x 36″. Courtesy of Mr. and Mrs. Arnold Hartikka.*

SOLUTION

In my paintings I like to see the elements of harmony and order. The picture should be well organized, not hectic and chaotic, and this is brought about primarily by a well-organized design. As I explained on the opposite page, the design element relates to value patterns as well as to subject matter. I dislike rules in painting, but one I often repeat is this: when in doubt—simplify.

Some of the esthetic concepts of a painting are difficult to put into words for the student—they almost have to be "felt" rather than specified. One way I attempt to explain this principle is that some areas of a painting have to contain more darks than lights, and other areas more lights than darks. This takes place in even a simple study of a

single tree. Many times there are several possible solutions to the problem at hand and I merely caution the student in a negative way: "Be sure *not* to get your painting spotty." Before you begin to paint, you must sense a definite pattern and design that will hold your painting together, and stick to it no matter how the light actually changes while you are working. This solution can be part factual, part imagined. The only rule I stick to as I depart from the literal is that "it *could* have happened that way." Dealing with elusive items like patterns formed by the trees and bushes above is not easy, but I trust you can see how the introduction of a definite and organized design has made this a painting instead of a record of the subject.

8. Vary Your Solution to the Same Subject

WINTER MARSH. *Oil on canvas, 24″ x 30″. Courtesy of Mr. and Mrs. Gerald C. Mullen.*

EXAMPLE ONE

One of the desirable qualities of an original piece of artwork should be its uniqueness; there should *not* be another like it. I am afraid this is not always the case. While casually walking around after serving as a judge at an outdoor art festival, I observed that just as a woman walked happily away with her new acquisition, the "artist" who sold it to her went into his van and came out with an exact duplicate. This is highly unethical (although the artist is unwittingly cheating himself as well as the purchaser), and it is also unnecessary. Without duplication, the same scene can be painted in different seasons, with different lighting effects, or with the conditions practically the same but given a different mood.

In this key I am *not* showing you a painting that is "wrong" in any way. Instead, I want to give you two examples of how to vary your solution to the same subject. The New England area has many wetlands that stretch between the ponds and lakes. You will notice them throughout this book, for I find their moods and seasons a wonderful motif and challenge. Here we see a cold, overcast winter day. I devoted most of the canvas to the pattern of brush-and snow-covered ice and less to the sky, in which I suggested just a small patch of light breaking the solid cloud cover. A painting like this is really an intriguing pattern and design—so much is suggested, yet the viewer thinks he sees greater detail.

DECEMBER DRAMA. *Oil on canvas, 24" x 30"*.

EXAMPLE TWO

Now, we have the same scene in an entirely different mood. A dramatic sky is opening up and the sunrays play down on the distant hills and lake. I hope you have noticed that in my work I quite often depict the actual rays of sunlight. What drama and feeling of sunshine this gives us! Under these conditions, I have naturally devoted most of the canvas to the sky. I have kept all the foreground in a cloud shadow and eliminated some of the middleground trees, so they would not interfere with the drama of light in the distance. Skies like this cannot be painted in your early years of development. They call upon every bit of knowledge of actual conditions, plus a feeling for rhythm and de-

sign. That is why I suggest you study skies constantly and make numerous sketches of them.

Early in my career, I met a wonderful, elderly, Italian painter, who had a poetic way of explaining things. It was he who taught me to "take the same meat and cook it in different sauces." Now, I pass this on to you. I trust, as you study these two paintings, you will see that there is no need to turn out paintings that are repetitious, hack work. In fact, if it was not for the marvelous challenge that art provides, and the inner satisfaction you have when you know you have met that challenge and conquered it, I am afraid I would not be writing this book for you.

9. Occasionally Tell a Story in Your Painting

PROBLEM

This key is a bit different from the others, inasmuch as I am not showing you something done *incorrectly* on this side. What I would like to stress here is the worth and importance of carrying sketching materials with you—and making use of them. Too many inexperienced painters are so concerned with "making paintings" that they overlook the importance of gathering information and knowledge by means of sketching. The above pastel study was done several years ago, on the spot, not pretending to be a great work of art but merely a fact-finding study. I discovered the subject while driving through a nearby rural area. The remains of the old house fascinated me. It had almost completely decayed and collapsed, but the central core of the house was still there, with flowers blooming around the base. It was almost as if the heart of the home would not die. For those of you not familiar with early colonial construction, an explanation here might help. In larger houses, the chimney was the central core of the building. This was a massive stone structure that each of the fireplaces fed into, and the hand-hewn beams attached to it. That is the reason why this fascinating structure was still standing—the part that was tied into the stonework remained as a reminder of the past. This sketch was done on toned paper with NuPastels. For more serious work I prefer softer pastels, but I had these in my sketch kit at the time.

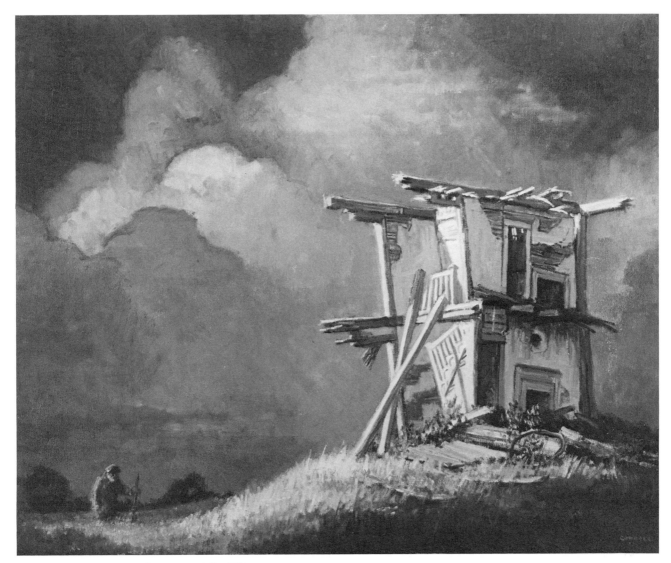

How Dear to this Heart. *Oil on canvas, 24" x 30".*

SOLUTION

The above painting is rather unusual because—as I believe I have mentioned elsewhere—I am a painter who does almost every painting on location. This is one of the exceptions. The pastel study hung around the studio for some time. It stirred my imagination and I wondered who had lived in the old house. Perhaps it had been some young couple's first home—their dream home—the place they raised their family. I thought of the tales it could tell of a bygone era if it could but talk. I recalled an oft-repeated bit of advice—to not try to recapture the fond memories we have of a time or place of long ago by going back to it, for it is often no longer as we remember it. Finally, these thoughts, and my background in illustration, prompted me to turn the study into a painting of a symbolic old man returning to the scene of a happier time and surely regretting that he had done so. A special sky had to be felt and visualized to enhance the mood I was portraying—an emotional experience like this could not happen on an ordinary, clear, sunny day. The title that seemed to be just right was the first line from the old favorite of yesteryear, *The Old Oaken Bucket*: "How dear to this heart/ are the scenes of my childhood/ When fond recollection presents them to view." Rather ironic and bittersweet, but so apropos.

10. Simplify Areas to Accentuate Detail

PROBLEM

As I mentioned before, a good rule of thumb to remember is this: when in doubt—simplify. In painting, you should decide what you're trying to say to the viewer and subordinate any conflicting and competing passages. The above painting is a classic example of trying to say too much and as a consequence saying nothing well. The canvas is almost divided into thirds—hillside, hill, and sky. All compete for your attention. With lights playing on the distant hill, we lose the emphasis that the foreground bushes should have. The sky is also far too busy. The clouds are not only similar in shape and size, but they run along parallel to the top of the hill line—a subconscious tendency of many amateurs.

Conversely, with the upper part of the canvas overplayed, the bottom half does not have enough detail. What texture could be achieved here! No effort has been made to exploit the area where the light grass comes against the shadow area of the bushes. The few wild flowers and clumps of grass are far too spotty. The dark hemlocks are repetitious in size and shape and terminate at the same point as the distant hill. This key is closely related to Key No. 41—creating depth by strengthening foreground detail. However, here I want to emphasize that the foreground detail would be *further* enhanced by simplifying the adjacent background areas, as you see in the solution painting.

AUTUMN HILLSIDE. *Oil on canvas, 24″ x 30″. Courtesy of Mr. and Mrs. Howard T. Brown.*

SOLUTION

This is a better painting primarily because I have played up what was important (and what I wanted people to see) and subordinated the rest. The hill in the background was more interesting than I painted it here—quite often a great sky came along, but I resisted the temptation to play these up and spent my time bringing the foreground to almost the refinement of a stillife.

A subject like this is one of nature's abstract designs— wonderful to behold and a challenge to paint. The various shapes, textures, and colors intrigued me. I gave careful thought to its execution and design: notice that I devoted most of the canvas to the main subject. With the distant hill held down as an atmospheric middle tone, the center bush, which is a brilliant gold, and the surrounding sumac, which is a spectacular vermillion, really command the attention they deserve. The foreground grasses and flowers were as fascinating as a Byzantine mosaic: the colors and design played against each other and the shadow area of the bushes. When you have a great thing going like this, remember—let it be the soloist and make the remainder of the painting "hum" an accompaniment.

11. To Bring a Painting to Life, Include a Figure

EXAMPLE ONE

A well-conceived and well-placed figure can do so much for a painting, as I hope you can see in comparing these two paintings. Students very seldom put figures in their paintings, and when they do, the figures are usually poorly drawn. The reproduction above shows you what my canvas looked like when I brought it home after my first day's painting.

Let me relate to you an interesting incident concerning this painting made many years ago when I only had weekends to paint. It was a sparkling, sunny morning and I had anticipated for some time painting this scene with snow on the ground. I had barely gotten the composition sketched in when the sky grew ominous—I soon found myself sitting in the middle of a snow storm with the snowflakes falling

on my canvas and palette. In those days I had less time to paint, so I was determined to continue, inasmuch as I was all set up and underway. From my car, I got out a large beach umbrella that I always carried, set it up over me, and decided that I could be as stubborn as the weather. The blowing snowflakes mixed with my paint and even got on the canvas. I decided philosophically that I would at least get an authentic study of a snow storm that I could copy later.

Over 20 years have passed since that incident, and the finished painting opposite is part of my permanent collection, with absolutely no sign of deterioration. Perhaps there is a moral to this story—if you are ever to succeed as a painter, a very important element is dogged determination.

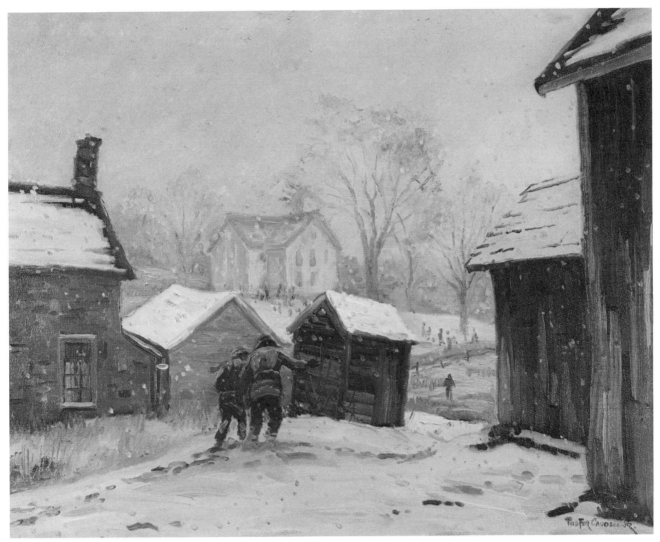

THE CENTER SCHOOL. *Oil on canvas, 22' x 28''. Private collection.*

EXAMPLE TWO

This painting goes back to the days when I was a very rapid painter. I usually completed a painting on the scene in one day—now I spend much more time, going back several times. As I have said, the painting opposite is the scene just as I saw it that snowy Saturday. I wanted to depict a vanishing part of Americana—the old Center School which dated back to Civil War days. As I studied it, the part that seemed missing was the kids trudging through the snow, crossing through backyards and fields on their way to classes, urged on by the tolling of the bell. This was an era long before the coming of our slick, yellow school buses. Yes, the missing ingredient was the children. So, the

next day, on Sunday, I put the figures into the painting. I tried to imagine how they would trudge through the snow, collars up, mufflers blowing, as they talked of most anything except the lessons that lay ahead. I feel I captured the mood and spirit of the subject, and the painting became much more successful and meaningful because of them. Looking back, I realize one of the things I enjoyed about illustrating was having the opportunity of depicting people in my painting. On the following pages I want to show you closeups of just how I handle figures in a landscape painting. I hope this will be helpful to you as you try the same thing in your own work.

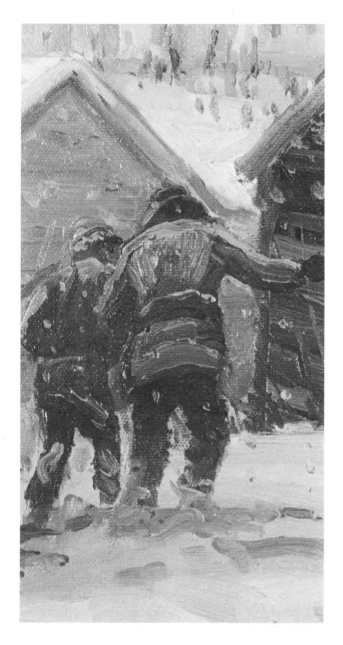 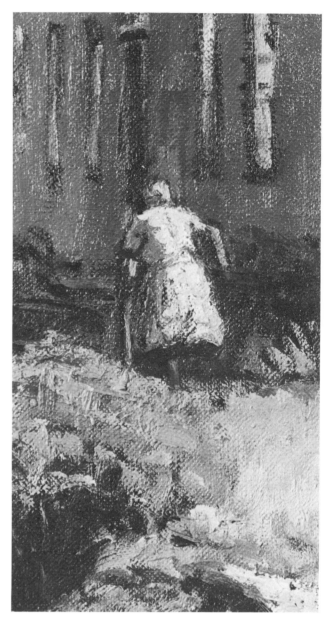

EXAMPLE THREE

This, of course, is a closeup of the figures in this previous
key; here they are reproduced almost the same size as they
were painted in the original painting. In this way you can
see exactly how they were handled. The main point I want
to bring out is that the figures are not rigid and stiff—they
feel as though they are trudging through the snow and
talking to each other. After some preliminary sketches, the
figures were painted in boldly and freely, in keeping with
the spontaneous handling of the rest of the painting. Of
course, there actually were no figures present in this scene
and the whole conception was purely out of my
imagination.

EXAMPLE FOUR

This is a closeup of the woman in Key No. 31. She came out
to see what I was doing, and as she hobbled back to the
house, I quickly painted her in. Later, when I showed her
the finished painting, she was disappointed that I had put
her in "back view." She told me she had lived in the house
all her life. One year, when she was a child, a sapling
started by the front steps and her father said, "Let's leave
it, it may amount to something." It became the huge elm
tree you see in the finished painting.

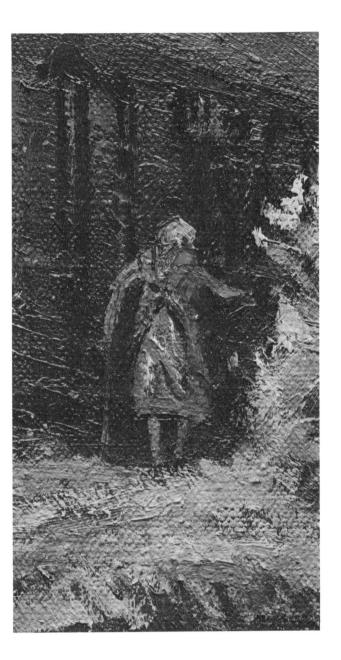

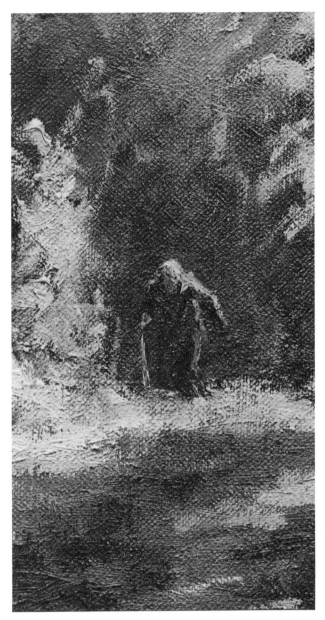

EXAMPLE FIVE

This is the figure in the Key No. 12. I seem to be always painting nice, little old ladies who come out to see what I am painting. By taking my ideas and inspirations from real people, I get a greater sense of authenticity and reality. Even though this is rendered freely, notice the suggested detail of the typical old cover-up apron, worn almost constantly by many old women. I also wanted to call your attention to the movement and action—my figures "feel" as though they are walking or doing something. Most amateurs make their figures too stiff and rigid. The solution is, of course, to do a great deal of sketching people, so when you have to put a figure in your painting you can do it well.

EXAMPLE SIX

This is the figure in Key No. 15, Example No. One. I never fail to take my source of inspiration from the real thing whenever it is possible. Usually there is someone walking about or engaged in some activity while you are painting. Make sketches of them if you cannot paint them in directly on the spot. Many students try to put a figure in when they get home, and I am afraid that in most cases the results are stiff, corny, and overworked. Here we feel the action of the old chap walking by his doorway. He looks like he belongs because he was actually there when I was painting. Notice how the same backlight that is in the painting as a whole is also on the figure.

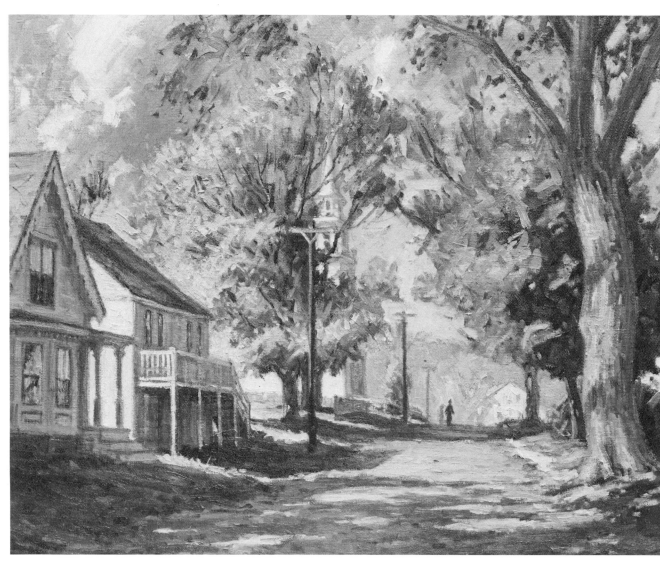

SUNDAY AFTERNOON. *Oil on canvas, 24″ x 30″. Courtesy of Judge and Mrs. Stephen A. Fanning.*

Light

In this section we shall take up the subject of light and I am sure you will begin to appreciate its importance even more than you already do. In our daily lives, light is all around us enabling us to see, yet we are hardly aware of its source and function until we try to put it into a painting.

You must learn there are two sources of light—the direct rays from the sun, and the soft top light from the sky.

The presence of light in your painting can be ordinary and uninteresting, or it can be exciting and dramatic, as it bursts into your canvas from a certain angle and flows across objects creating form and shadow patterns. I am very conscious of what I term the "drama of light"; it has always had a strong appeal and fascination for me, and I have long admired it in the work of the old Masters who used it so well, like Rembrandt and Caravaggio. To me, the patterns created by the drama of light on a subject are just as interesting as the subject itself.

I seldom see a student make the mistake of using too much light in his work. Most amateurs are hesitant to exploit its possibilities, and usually end up with a rather flat painting that does not convey the feeling of sunshine. They do not seem to be aware of this while they are painting outdoors, but then are disappointed when they take the canvas indoors where it seems to go "dead."

It takes years of experience to know how to strategically use lights and darks in your work so that it captures the beauty and sparkle of nature.

12. Choose the Best Lighting for a Subject

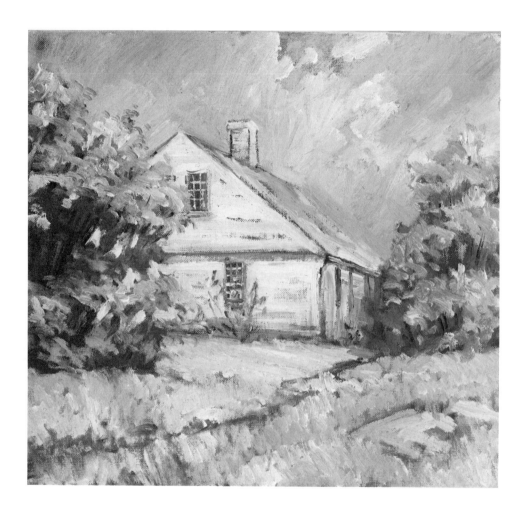

PROBLEM

This problem is one of the major failings of all amateur painters, although the longer you paint, the more you will be conscious of patterns of light and dark *on* the subject matter as much as the actual subject matter itself. Here the subject is an old mill house in our village. As you can see, without strategically planning a design of lights playing against darks, we have a rather flat, monotonous painting. Usually what prevents this is the angle of the sun.

Many times, in my early painting career, I would see subjects that I thought would make a great painting; not having the time or necessary materials, I would promise myself to return another day. Upon my return to the spot I would wonder what I had been so excited about. This change was caused mainly by a different lighting on the subject. You see, I failed to note what time of day created the lighting that had made me so enthusiastic about the subject. You can readily see in the painting above how the *wrong* lighting can make even an interesting subject rather unappealing. When everything is illuminated and high-keyed, it all shouts for attention. Never depend on just colors registering against each other; always play lights against darks.

Notice that in my problem painting I did not use a figure in order to demonstrate to you how much more interesting the solution painting is by the inclusion of one. We deal more with this subject in Key No. 11.

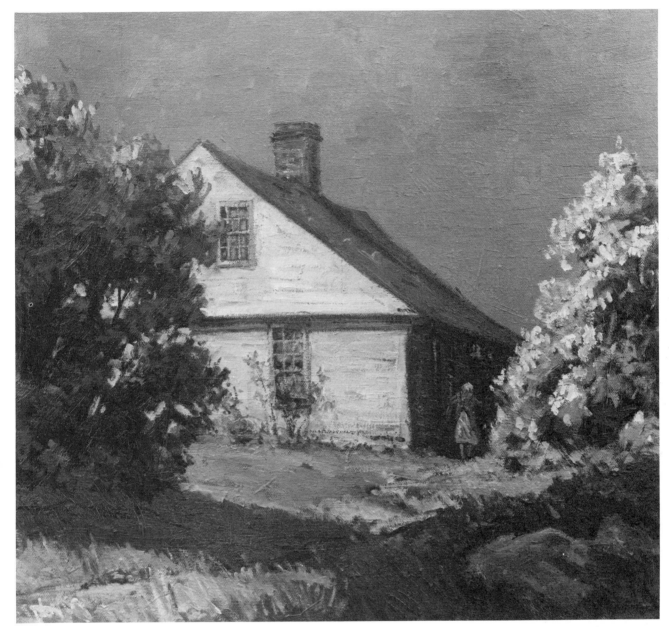

EMMA'S PLACE. *Oil on canvas, 23½″ x 26½″.*

SOLUTION

We can see how much more effective this subject is with a light coming from the left rather than from the right. I took the liberty of making the value of the sky darker than it actually was, thereby keeping the focal point down on the lower part of the painting. The dramatic contrast of the dark side of the lilac bush on the left creates a foil for the play of light on the weathered boards of the old house. Now the exact opposite happens on the right side of the picture, as the dark side of the house becomes a foil for the lights on the lilac bush in blossom. The strong diagonals of shadow pattern in the foreground help the overall design, and also limit the amount of light in the picture, making the remaining lights much more effective. The lights on this painting are no brighter than on the problem painting, but see how much more important they are played against darks. Old Emma, a hearty New Englander who lived alone in this old mill village cottage, brought me out a piece of mince pie she had just cooked on her wood-burning stove. I could not resist putting her in.

13. Play Lights against Darks, not Color against Color

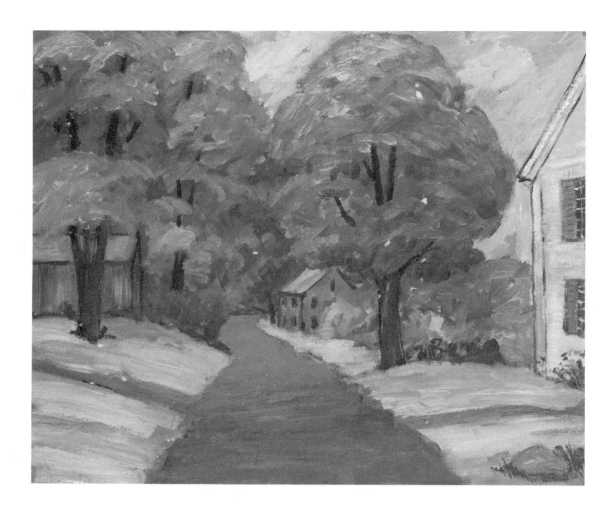

PROBLEM

A familiar phrase that I often hear from students as they attempt to make a picture is, "But I don't know how to mix the colors." My standard reply is "Color is difficult and takes years of experience—even if you can't get the color, but sure to get the *value*." In the making of a painting, not a "picture," value is more important than color. It takes some time for the amateurs to realize this, but once they do, their work is greatly improved. A black and white photo of a painting is a marvelous way to see if you have used values strategically. The above painting shows what it looks like if you have not—it is flat and has no snap because it has been thought out only in terms of colors. The

tree masses lack form; values create form, but here the values have not been designed to play lights against darks.

The trees are also uninteresting in shape; the amateur often reverts to symmetrical solutions such as these. Other typical mistakes that the inexperienced make are: designing the road symmetrically up the center of the composition; painting the house on the right almost the same value as the sky, making it necessary to draw lines to delineate it; and placing the tree on the right so that it just manages to touch the house and also the top of the canvas. Never have items touch—either overlap the design or back them away. Finally, notice that no attempt has been made to realize texture and design in the grass area.

SUMMER AFTERNOON. *Oil on canvas, 24″ x 30″.*

SOLUTION

In this painting we can see how the whole scene is brought to life by the careful consideration of values. I wish you could see this in color, because it has beautiful colors, but the point I want to make here is that the colors would be meaningless without the proper consideration of values. The gradation of values creates a sense of form not conveyed by color alone, forms register against each other without the use of outlines, and lights against darks create sparkle and sunshine. Notice that not only are the trees designed for variety of forms, but also that their lights and darks play against each other in an interesting way. We can now also "feel" the sunlight flowing across the whole scene. See how I have made the house on the right a darker

value and the sky behind it lighter. The shadows cast by the house and tree in this stronger lighting now flow over the road and up the bank on the left, giving us a great feeling of form.

With the road now off-center, the entire design is less symmetrical and each lower corner of the painting has a different solution. Grasses and weeds have been developed into an interesting pattern and the introduction of a portion of a stone wall on the right adds more interest. The road has been converted to a rustic, dirt one, and a small figure carries us into the painting and creates not only interest, but a sense of scale of the surrounding items.

PROBLEM

This key is so important that I am giving you another example of it. Compared with the previous picture, which was quite complex in design, this painting is a simple geometric structure. The way some houses are added on to, and the subsequent patterns created by lights playing on them, has long held a fascination for artists. Here we can see that the absence of this feature—the juxtaposition of lights against darks—combined with thinking only in terms of color, not *value*, creates an effect totally unlike sunlight. Rather, it gives us the feeling of a foggy day—an effect that is entirely accidental.

This was an old house I found some years ago on the island called Martha's Vineyard. The owner was rather upset that I chose to paint the rear of it rather than the front, but I chose this side because of the interesting patterns the sunlight made on it. The sky here is very ordinary and flat—as it actually was the day I painted it—but see how ordinary a painting resulted from being too literal. The grass area has not been exploited to its full potential and the painting is worse because of it. This old house needed a much more dramatic interpretation than a straight factual representation, and on the opposite page you can see one way of handling it.

THE WIDOW'S WALK. *Oil on canvas, 30" x 36".*

SOLUTION

Most of the mood is created by the use of lights against darks, rather than color against color. You can see how the whole scene was given a much more dramatic and interesting sky—notice how this was planned as a dark against the light side of the house on the right, and as a light against the dark side of the house on the left. The house itself now becomes a fascinating abstract pattern of light areas playing against darks. In handling the hill, I first painted it darker to achieve a feeling of weight and bulk, then painted the lighter grass over it, always mindful of creating a pleasing pattern of light against dark. Observe how the dark area is continued by the silhouette of the old

picket fence—even though there are some remains of white paint on it, the fence need not be painted light.

Just about the only change in design I made was to give the hill more curve and to exaggerate the perspective on the house a bit; this created a greater feeling of the house being perched on the top of the hill. To give the viewer a feeling that all this took place by the ocean, I introduced some seagulls in the sky; look how even this small note was thought out in terms of values and not just color. With the introduction of a figure, and the "widow's walk" (by the chimney) now showing up more prominently, we have established a mood that is only limited by our imagination.

14. Group Lights and Darks to Avoid a Spotty Painting

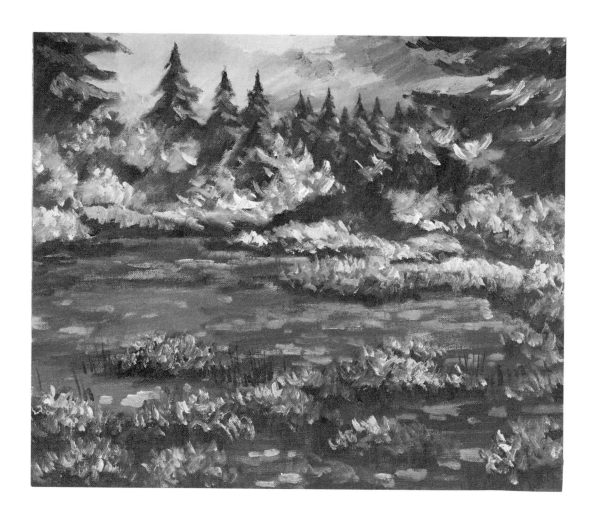

PROBLEM

This key is devoted to probably the most important single factor that will take your work out of the amateur class. Perhaps because it deals with esthetics and not something tangible, it seems to take years to understand and utilize. The failure to apply this principle results in a spotty painting and you can see evidence of it above. There is no organization to the pattern of lights and darks as they play against each other all over the painting.

The basic composition in this problem painting is not too different from the solution, but contains the following errors. The foreground grasses and plants have not been strategically designed to enhance the flowing S-curve of the brook, which enters at the lower left corner and doubles back and forth across the canvas until it swings around the bend of the stream in the center. The fir trees in the distance are badly handled—they look like Christmas card trees in design, with their pointed peaks—and the tree on the upper left is almost the same size as the one on the upper right. Not enough consideration has been given to the reflection patterns in the stream.

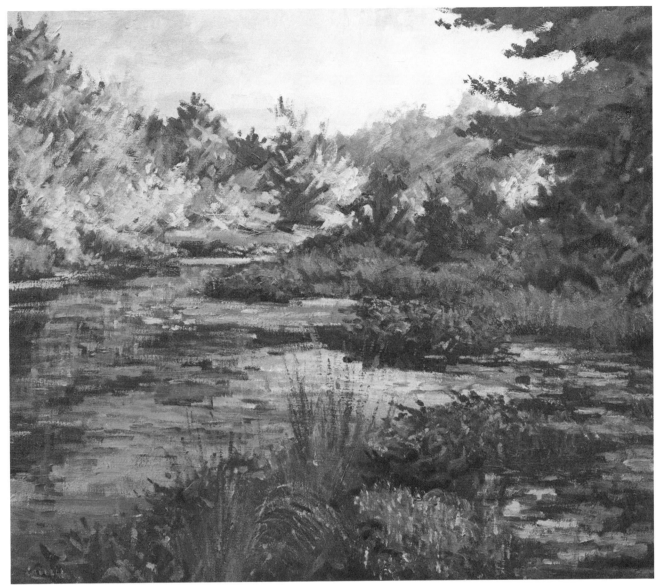

SUMMER STREAM. *Oil on canvas, 20" x 24".*

SOLUTION

My suggestion that you group your lights and darks together is another way of saying that some portions of your painting will be predominately light passages and others predominately dark. A handy device in achieving this, which you will find me using many times, is to theorize a mass of trees outside the picture area casting parts of the composition into shadow. Try never to end up with an area in your painting evenly divided between lights and darks—have more lights than darks, as in the bank on the upper left of this painting, or more darks than lights, as in the lower right section. (Occasionally there were lights that did poke through the trees and fall on the peninsula coming out from the right, but I ignored them.)

Notice how I corrected the other errors in the painting.

I redesigned the sky so the lightest part is the side that the sun is coming from; this nicely silhouettes the massive pine on the right. The pine on the upper left side was designed within the canvas height to give a feeling of progressive diminution. The canvas was divided as usual into foreground, middleground, and distance, with the appropriate progression of values in each. A great deal of consideration was given to the foreground grasses and plants. First they were designed to enhance the lovely curve of the stream, then they were executed, playing lights against darks, even though there is no direct light falling on them. I also made their texture and pattern as diversified as possible to avoid monotonous repetition.

15. Limit the Amount of Light in Some Paintings

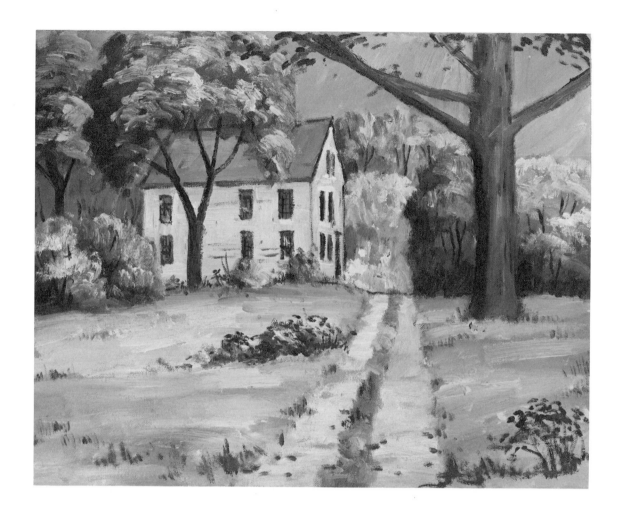

PROBLEM

Most amateurs do not know how to use the "drama of light" effectively in their paintings. It is an element that once understood and utilized can improve the caliber of your work tremendously, but unfortunately it is often missing, as in the painting above. I might go as far as to say that a great deal of work has little feeling of light at all—where it comes from, what interesting patterns it creates as it flows over the terrain, and how sparkle is created by carefully designing lights against darks.

The above painting has many other obvious faults; try to define them. For example, the lighting is flat and as a consequence the painting is rather ordinary. The road is too vertical and rigid, and notice how the lilac bushes behind the big tree exactly align with it. For some reason students are baffled by houses situated above their eye level and fail to give the perspective sufficient slant. The large tree on the right is very rigid and the ones on the left too stylized and symmetrical. The flow of design to the hill has been leveled rather than accentuated, and we are much too conscious that the old house even though faded is, or was, "white."

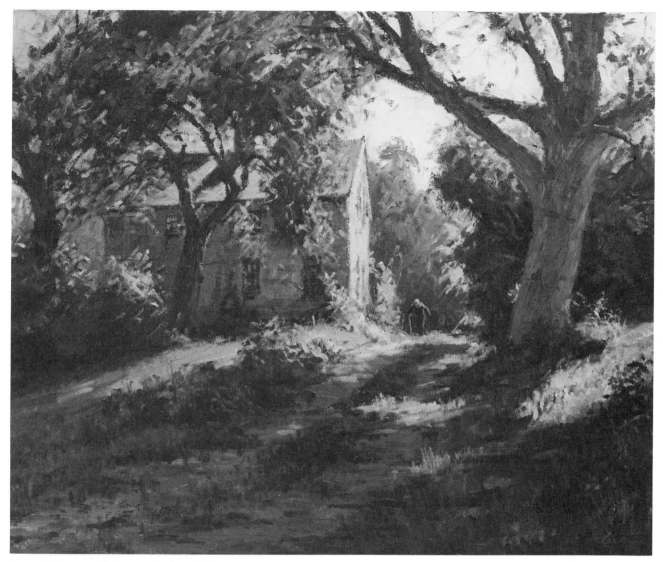

SUMMER MORNING. *Oil on canvas, 24″ x 30″.*

SOLUTION

In this painting the early morning light virtually sparkles as it plays on the house and splashes over the lawn and around the big tree. The most significant reason for this is that I have limited the amount of light in the painting and what remains has greater registration against the darker passages. This painting is actually three-quarters shadow—lights register against darks and not against other lights.

Let us consider what other factors make this rendition of the subject so much superior to the one on the left. The slant of the hill was increased and the big tree on the right curved to accentuate and coordinate this rhythmical sweep. A great problem the amateur has is to be specific in drawing but not to be stiff; there is a soft, flowing drawing to this whole painting. Notice how the windows, especially on the illuminated side of the house, are soft and "felt," rather than being hard, sharply delineated rectangles. Of course the road is now more diagonal and has been softened with a decorative use of grass and weeds. I felt the center of interest desperately needed a little figure and its inclusion brought the painting to a satisfactory conclusion.

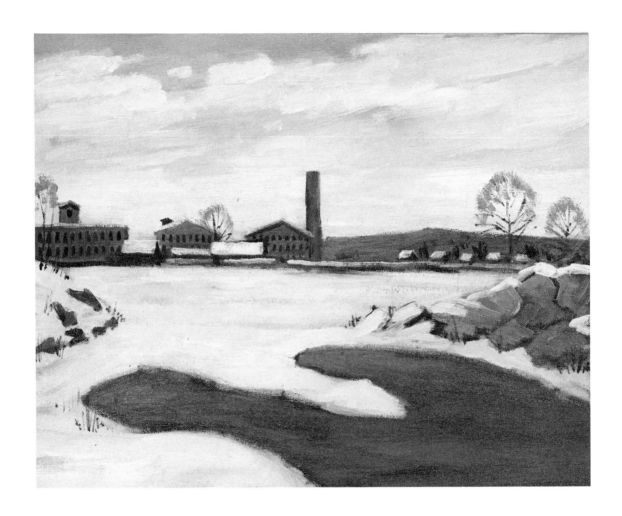

PROBLEM

This is a device I use quite often in my painting, so I wanted to show you an additional example, this time in a snow scene—which the amateur immediately thinks of as being mostly white. Light, like many other things in life, becomes more important by its scarcity. If we do not use much of it, what we do use becomes important. Because almost everything has been painted white in this painting, with no sense of the "drama of light" or its consequent shadows, we fail to have a feeling of light at all. The composition is unfortunately divided in the middle, so that we have a sky filled with clouds which rival the snow for attention. If less canvas were devoted to sky, more could have been used for the foreground open water, which, in-

cidentally, is badly designed here. The water is so rigid it looks like a jigsaw puzzle with a piece missing.

Many times the amateur gives some items too much attention and others not enough. Here all the windows are put into the distant mills, but very little consideration was given to making the foreground more interesting. Paintings like this are often made from a photo or a poor reproduction, and because the artist lacks first-hand communication with the subject, his picture usually leaves much to be desired. Compare this with the opposite painting, which was made on location over a period of three mornings, with an average temperature of 15°. I jokingly tell my students they must learn to suffer for their art.

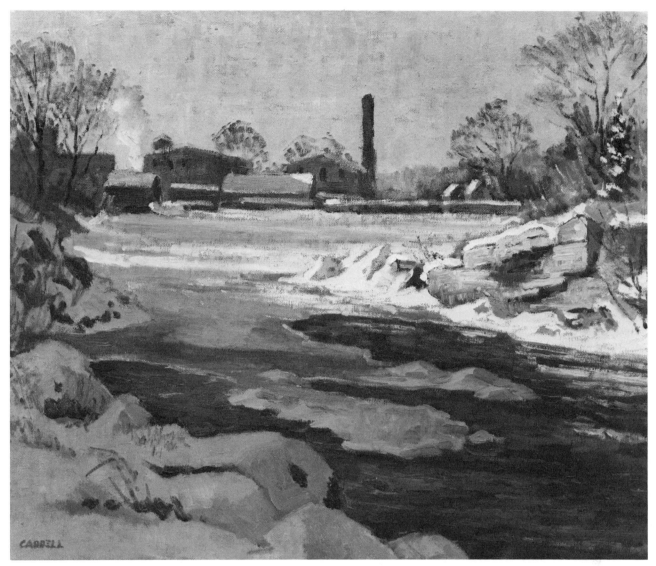

FEBRUARY MORNING. *Oil on canvas, 16″ x 20″. Courtesy of Mrs. Foster Caddell.*

SOLUTION

As I'll discuss in Key No. 25, the amateur thinks that if he doesn't paint snow "white," it won't look right. No one would doubt the authenticity of this scene, yet less than 20% of it is really light. Even the sky is held down in value so we can see the boiler room steam rising in the crisp morning air (these little details one only gets by being on location). My choice of early morning light—a time when the sun's rays just skim across the pond and climb over the snow-clad rocks, leaving most of the snow in shadow—gives us an unusual solution to the light problem. Remember that the drama of light *on* the subject is as important as the subject itself.

Notice the other improvements I made on the problem painting. Even though the foreground snow is painted in low key, it appears luminous because it is adjacent to the dark, rich tones of the open water. Most unskilled painters do not give sections like this enough attention—they should be painted with the same sensitivity you put into a still life. An emphasis on detail in the foreground, with a more casual suggestion of it in each succeeding plane, is a marvelous help in creating distance and depth. I have dwelt on this further in other keys. The overall detail in this painting is much less specific than in the problem one, but it does softly tie the entire subject together.

16. Make the Focal Point a Tonal Climax

PROBLEM

The professional artist actually controls what people see in his painting—he has learned that the viewer's eye goes to great contrasts and casually glides over close tonal relationships. This is a general concept that is not just applicable to landscape painting. As I write this in my studio, there is a large figure painting above me which exemplifies this very same principle. The tonal climax of lights and darks takes place at the head, and the lower part of the body and hands have a much closer value relationship. In this demonstration painting, the darks and lights are scat-

tered all over the composition and as a consequence our eye does not settle anywhere in particular. Again, remember the rule: when in doubt—simplify. The painting is jumbled and spotty. There are three distinct progressions of land masses but they have not been kept separate by the handling of values. The line of trees across the top of the painting is too uniform and contrived—even if it happens this way, do not paint it literally. Notice how this problem is solved on the opposite page. It is not only a more interesting line but the progression of heights into the painting is a great device to create depth.

TRANQUILITY. *Oil on canvas, 16″ x 20″.*

SOLUTION

There is little question but that your eye goes to the pine tree on the peninsula on the right. Why? Because there I have combined the darkest darks and lightest lights into what we refer to as a tonal climax—and it commands your attention. Try turning this painting upside down so that it actually becomes an abstract design; again, your eye goes to this same spot. This principle cannot always be used as simply and directly as in this painting, but to a great extent it can usually be used to bring the viewer's eye to the focal point. I kept the area behind the pine light in value by dramatizing the early morning light penetrating the mist. The light coming through the trees falls on a few choice bushes, which are almost cadmium yellow pale against the dark viridian of the pines.

Turn your attention now to the bit of land on the left. The birch trees here do not appear as distinct and snappy as they do in the problem painting, but I did keep the background behind them rather simple so they would register against it. The foreground water was carefully designed so as not to become too spotty, even though it contained lots of pond lilies. Notice how the lily pads not only subtly diminish in size as they go back, but also lead the eye with a flowing design from the lower right hand corner, across the painting, and then into the center of interest.

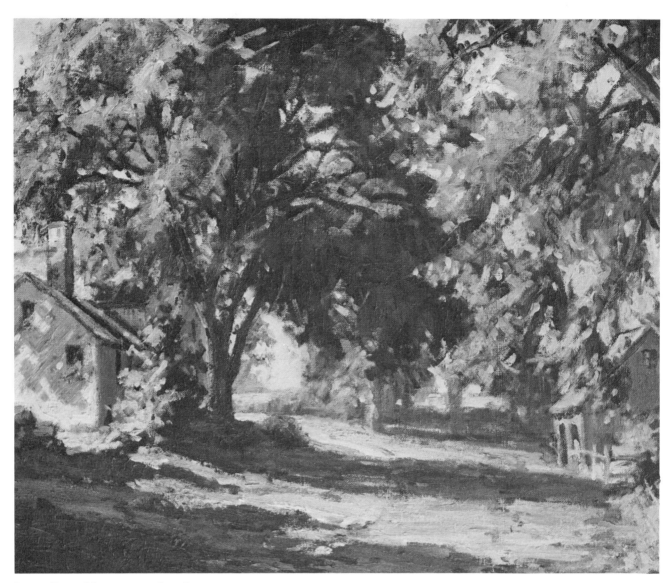

SUMMER ROAD. *Oil on canvas, 16″ x 20″.*

Shadows

Shadows, if they are painted correctly, give us the brilliance in the light passages, for in painting, as in life, all things are relative. Shadows are created in a painting by the proper use of values, which are the progressive tones on the scale from light to dark. Values are more important in a painting than color. I hear students say so many times, "I don't know what color to mix," when they should be first and foremost considering the value of the passage.

An artist who used to go sketching with the famous landscape painter Corot, relates that the master took along a square of white linen and one of black velvet. These he would throw on the ground in front of him as he painted, so he could judge the relative values between white and black.

Study the paintings in this book and you will see how much thought and consideration I give the shadow passages in them. The longer I paint, the more importance I place on the design element of lights and shadows. If no one has taught you to "squint" in your observation of the subject, let me here and now stress the importance of this means of observation. It simplifies areas, and I actually paint shadows the value they appear when my eyes are almost closed.

17. Emphasize the Dark Shadow Sides of White Buildings

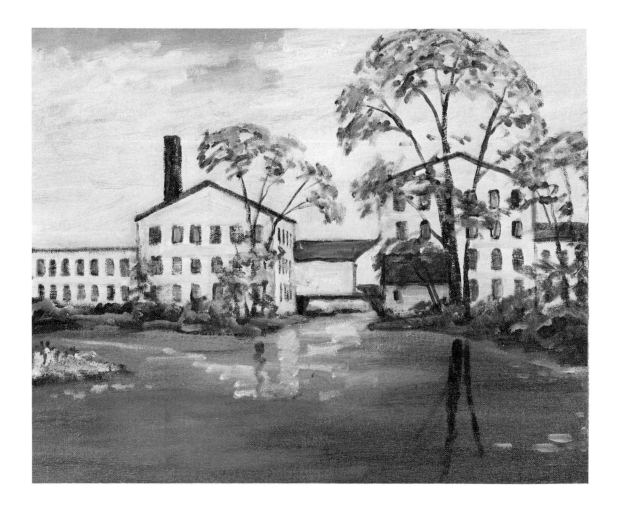

PROBLEM

One of the major stumbling blocks the student has to overcome is being dominated by what he *thinks* things are or should be, rather than being analytical and seeing them clearly and literally. This is especially true when it comes to painting white buildings. The light sides of white buildings are usually lighter than the sky, but the shadow side is invariably *darker.* This stumps the student for some time because to him "white" is "white." Before he will paint it otherwise, I must first teach him to squint in order to see the true value, and then—the hardest part of all—convince him that he must paint it that dark. The unskilled attempt is usually like the above painting, which depends upon lines to separate the items. The buildings, for example, are too similar to the value of the sky and need a hard line to define them.

Another common mistake in a subject like this is that too much time was spent on some passages and not enough on others. Just because the buildings have many windows, you do not have to put them *all* in—here is where you should "suggest." The water, on the other hand, has not had enough thought and work: painting beautiful reflections is not as difficult as you might think. Unless the surface is broken by wind ripples, it reflects the items *above* it. And, to the extent it reflects one item, it should reflect them all—not as in the demonstration above, where you see tree trunks without a building on the right and no reflections on the left.

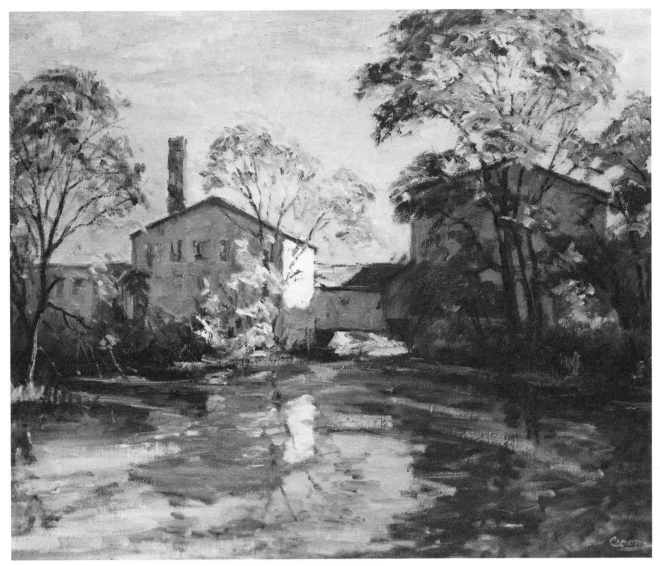

THE WHITE MILL, AUTUMN. *Oil on canvas, 16" x 20".*

SOLUTION

The viewer certainly accepts these buildings as being "white"—they have much more solidity and the light side is more sparkling because I painted the shadow side sufficiently darker than the sky. I mention this because so often when I place this value on the work of a confused student, he says, "But if I paint it that dark, it won't look 'white.' Their minds prevent them from seeing and subsequently painting it correctly. There is actually less light in this painting, but it looks brighter and snappier. Now the bright, golden autumn leaves register against the shadow side of the center building.

I have corrected some of the other mistakes made with this kind of subject. Notice how the water is handled.

There is now a consistency to the pattern of reflections, and I have designed the flow of the stream with wind ripples coming out of the sluiceway on the left, sweeping across the pond, and exiting again at the bottom left. Look—study—apply—the answers are right before you if you can but learn to see them. The trees are much more decorative than in the problem painting. The large elm on the right goes out of the painting and no longer just touches the edge of the canvas. I introduced a tree into the peninsula on the left—see how the progression of height from this to the tree in the center leads your eye down to the center of interest.

18. Utilize the Decorative Cast Shadows of Trees

PROBLEM

Throughout this book, you will notice how often I employ the principle of this key. In any painting you should aim for the most artistic interpretation possible of the scene, and I find shadow patterns are extremely helpful. I make the most of them when they are there and even improvise them when they are not. Frequently I have had students ask, quite sincerely, "Do I put the shadows in also?" Many times, painting alone, they ignore shadows completely, as in the painting above. By comparing the two paintings, you can readily see how desirable and helpful shadows can be if handled correctly. The general composition in both instances is quite similar. The road is going right up the center, but in the problem painting, without the modifying shadow pattern and soft handling of edges, the road is most bothersome.

The other mistakes here bear repeating, even though I have gone over them in other keys. Students invariably have problems drawing the correct perspective on a building situated above eye level. Also, they tend not to paint the shadow sides of white houses sufficiently dark. The tree patterns here are repetitious in size and shape, and the handling of the grass area is a total disaster. No matter how charming a scene may be, if the painting lacks a sensitive and educated approach to the problems, we can end up with a most unhappy solution, such as we see here.

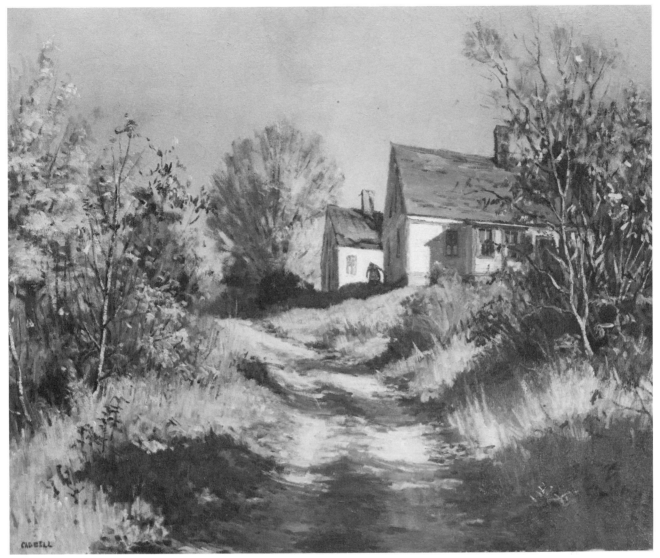

BEACH DALE LANE. *Oil on canvas, 24″ x 30″. Courtesy of Mr. and Mrs. Emerson R. Naugle.*

SOLUTION

Study the above painting and you will learn a very important lesson. I have stated elsewhere that the pattern and design of lights and darks are as important as the design of the objects themselves. Two main points have been achieved by the use of shadow patterns in this painting: (1) shadow patterns have broken up and tempered the unfortunate linear design of the road, and (2) they give the viewer a marvelous sense of form and texture in the areas they pass over. Let us go into detail about the first point. The horizontal pattern of the shadows over the road is now a more dominant factor than the vertical design of the road itself. Notice how cleverly the shadow shapes are made larger in the foreground and diminish as they go back into the picture—what a marvelous device to aid the illusion of depth. Now let us discuss the second point. The feeling of form and contour to the land and grasses is greatly helped by the drawing line on the edges of the shadows. We feel the hard-packed, concave shape of the wheel ruts and the vertical depth of the grasses and weeds mostly because of the diversified handling of the shadow pattern edges.

It takes years of painting to see pattern and organization in what at first looks like a lot of weeds, but when you have mastered it, you are well on your way to becoming a successful landscape painter. Study how I have incorporated this principle in other keys and begin to analyze its helpfulness.

19. Make Shadow Directions Consistent

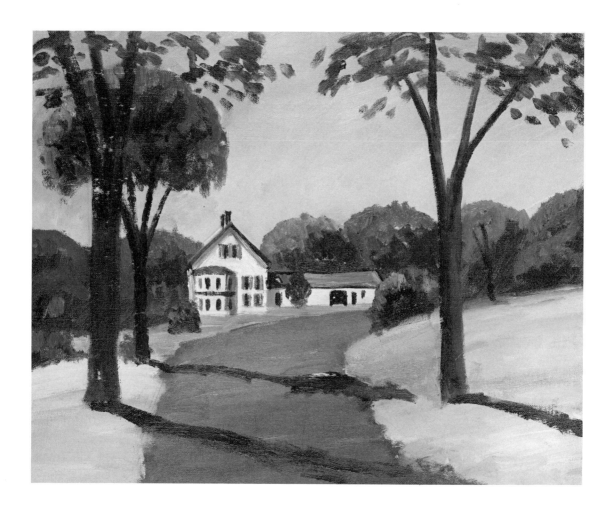

PROBLEM

Probably this, like some of the other keys, at first seems so obvious that you wonder why I give it so much importance. However, many students make this mistake—most frequently those who are accustomed to only studio painting, where the direction of light and the consequent cast shadow remain stationary. One of the first principles I teach the student about painting in the great outdoors is that not only does the intensity of the light vary, but the direction does also, as the sun travels across the sky. The first morning on location with a new subject the artist must decide at what time of day the shadow patterns are the most interesting, and stick to that interpretation no matter

how much things change. This was not done in the above painting. Although each statement *could* have been an absolute truth when painted, it could not all happen *at the same time*. When the sun bathed the front of the house, it was coming in as a left front light, yet the cast shadows from the foreground trees had to come from a left backlight. The sun could change direction this much during a morning or an afternoon, but the artist should not include these inconsistent variations in his work.

Other obvious mistakes are: the foreground trees are too much the same in size and design; the background trees repetitious in form; and the road appears to go uphill because it is not wide enough in the foreground.

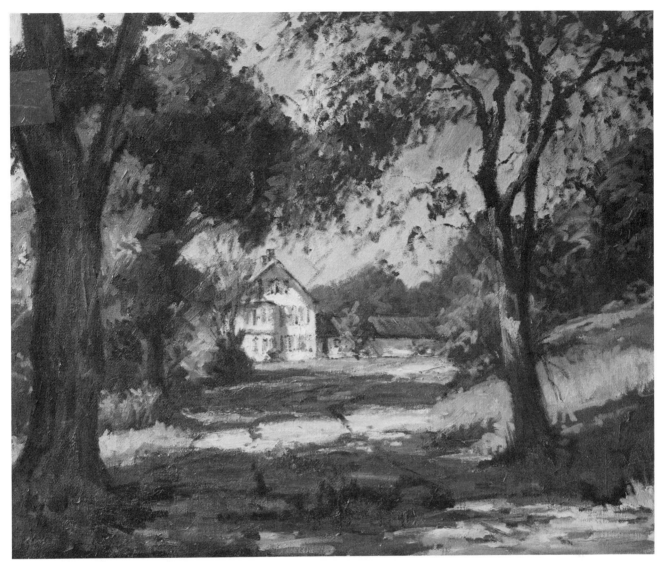

REGAL VICTORIAN. *Oil on canvas, 24" x 30".*

SOLUTION

In the above painting you can readily see that the shadow and light patterns are consistent—the morning sun that hit the old house would throw the tree shadows backward, not forward. Also note how I have used these tree shadows in a decorative way. You can give a feeling of the terrain by the way shadows play over it—notice how they climb the bank on the right. Even the edges of shadows can say texture; see how I handled the grass as compared to the road.

Let us go over other things I have done in this painting to improve it. The tree on the left was brought forward and enlarged in size, giving us a definite progression in trees as we go back into the painting. (I discuss this further

in Key No. 38.) The road was improved in design and converted to a dirt road, which lends a great deal more charm to the scene. Turning to tree foliage—the secret here, and in all design problems, is diversification; try to avoid falling into the trap of repetition. The near tree on the left has only a small amount of foliage showing, with sky above it. The next tree back on the right has a different trunk design, which I made the most of, and the foliage goes out of the canvas in a lacy, decorative way. The next tree back on the left is more solid and is all within the composition. The trees in the far distance are all varied in pattern.

20. Paint Luminous Shadows

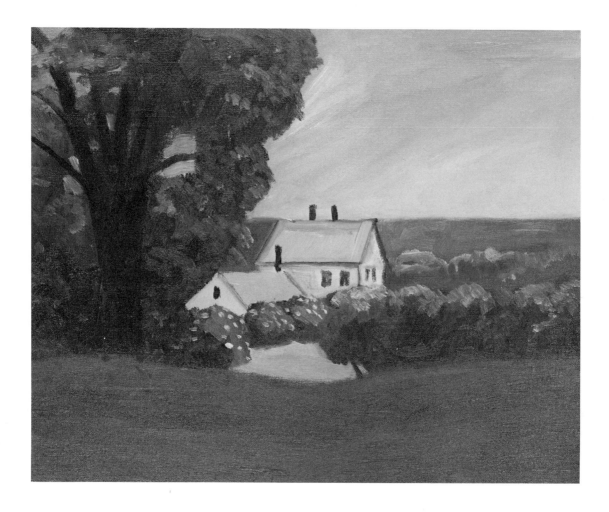

PROBLEM

The principle of creating luminosity in the shadow areas is most illusive to the student. It involves the correct use of values, which I feel, is in most cases more important than color. Shadows are illuminated by the secondary source of light—the sky above. The primary source of light is, of course, the direct rays of the sun. Brilliance in the directly sunlit area is conveyed by achieving the proper depth of value in shadow areas. In attempting this many students go too far, and the shadows become heavy and leaden as we see here. The correct value is extremely critical, for if it becomes too light, we lose the big design of lights and darks that we have discussed in other keys.

In this composition, too much space has been given to the foreground area: the canvas could be used to greater advantage by lowering the foreground and using more space for the decorative branches at the top. The shadow side of the house is too white: as I mentioned in Key No. 17, it seems difficult for the student to paint shadow sides sufficiently dark. Other bad mistakes are: the unfortunate alignment of the distant hills with the rooftop; the repetitious shapes of the bushes; and the lilac blossoms that are painted on spottily, like measles. The big elm divides the upper canvas almost in half, and the sky area needs a pattern of clouds to make it interesting.

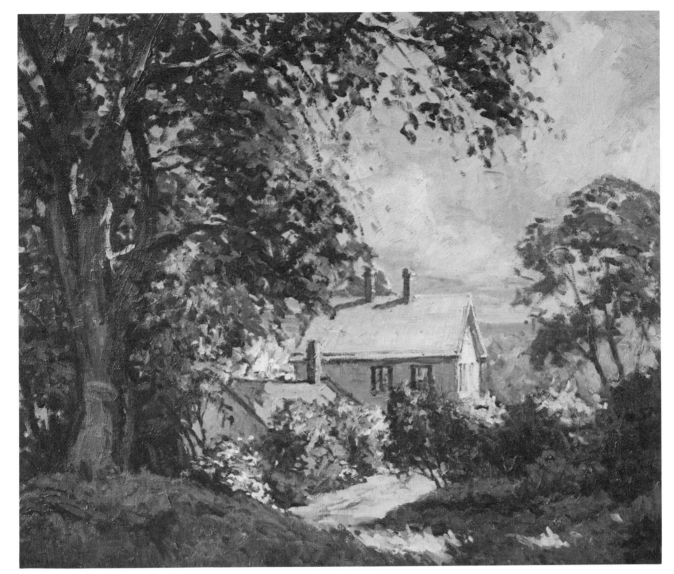

LILAC TIME. *Oil on canvas, 24″ x 30″. Courtesy of Mr. and Mrs. Gary Roode.*

SOLUTION

Incorporating a range of values within the shadow areas of a painting without destroying its solidity of design is not the easiest thing to accomplish. But, if it is done correctly, as we see here, we can maintain brilliance in the lights and achieve luminosity in the shadows. Notice how the luminosity is helped by strategically using *very dark* darks here and there, which make the general shadow areas look relatively lighter. A good example of this are the darks behind the tree trunk on the left.

The foreground has been given a rhythmical curve and flow which leads us down the path to the center of interest by the house. With more area at the top of the painting, the large elm has been expanded farther over in the composition and the sky area has been helped with a subtle de-

sign of clouds. To balance the composition, I introduced another tree on the right—notice how it leans *into* the picture. The hills are now atmospheric in value and color, and the added tree helps push them back into the distance. The designing of shapes such as trees and bushes is something that takes years to learn. Gradually you will "feel" a pleasing rhythmical design and incorporate it into your work. When you can successfully do this, you will have mastered a major step towards professional painting. As I mentioned in Key No. 8, you can often find possibilities for several paintings in one area, if you look for them. This is the same house that I painted in Key No. 19 (consistent shadow directions).

21. Paint the Foreground in Shadow for Dramatic Lighting

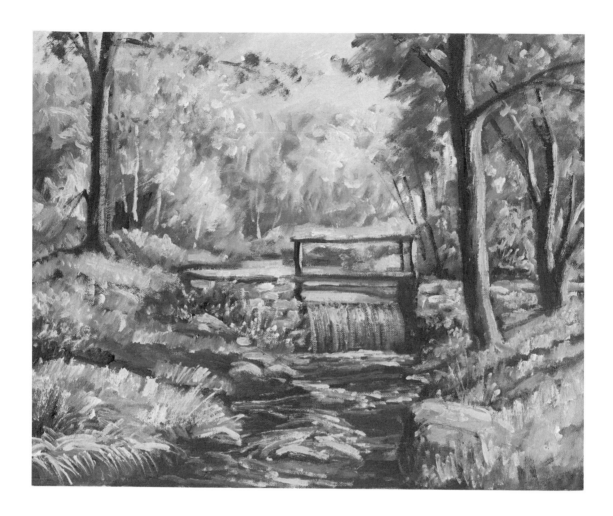

PROBLEM

In my effort to expose you to a series of different solutions to your painting problems, you will find certain basic premises occurring and reoccurring. I have long been aware of the drama of light and its strategic application in painting. Almost all my work is as much a study of light *on* objects as it is of the objects themselves. One general comment I am constantly making to my students is, "Be careful—don't give them too much." This can apply to color, detail, or lighting, as in the painting above. When every passage is of equal importance and emphasis, the viewer's eye does not know where to light and it wanders constantly over the painting. I have purposely kept this problem painting very much like the solution. I have not incorporated other problems such as composition, the angle of illumination, or amount of detail in order to demonstrate one point—lighting. Light can hardly have drama if it is used all over. The decisions you make about *how* to illuminate your subject can make *your* painting much more effective than someone else's—this is one way to take your work out of the realm of the ordinary.

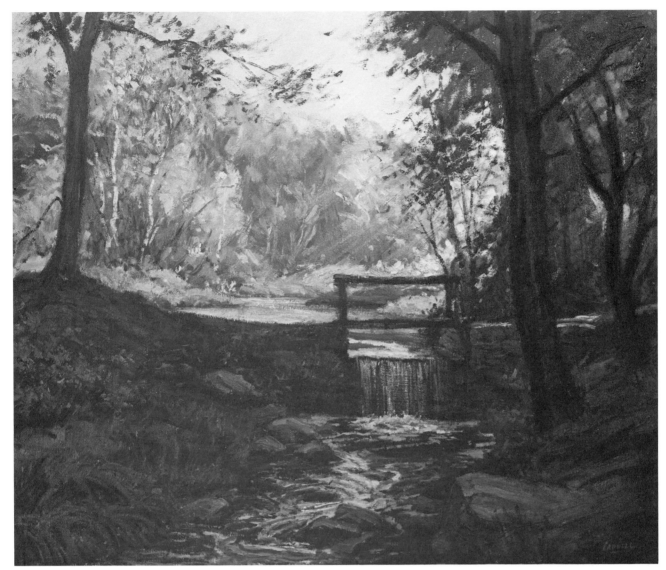

PHILLIPS POND. *Oil on canvas, 24″ x 30″.*

SOLUTION

There is no question that this interpretation is much more interesting and artistic. Because of the large trees to the right of my subject, the foreground was in various stages of light and shadow at different times of the morning. Before you begin your painting, you must have already decided on a solution to almost all of your problems, and in this painting I decided to throw the entire foreground into shadow. Even though the foreground is handled an octave lower, there is still detail and luminosity that is even evident in a black and white reproduction. The dam and old

bridge become an interesting silhouette against the reflections on the pond beyond. The dark mass of trees on the upper right is a powerful foil for the morning sunlight streaming down on the marsh grasses and trees in the distance. Actually they are no lighter than in the problem painting, but see what attention they command when potentially competing areas are held down in value. The sparkling stream picks up light from the sky above and gives the foreground lovely detail and variation without upstaging the pond area in the rear.

22. Dramatize a Composition by Adding Cloud Shadows

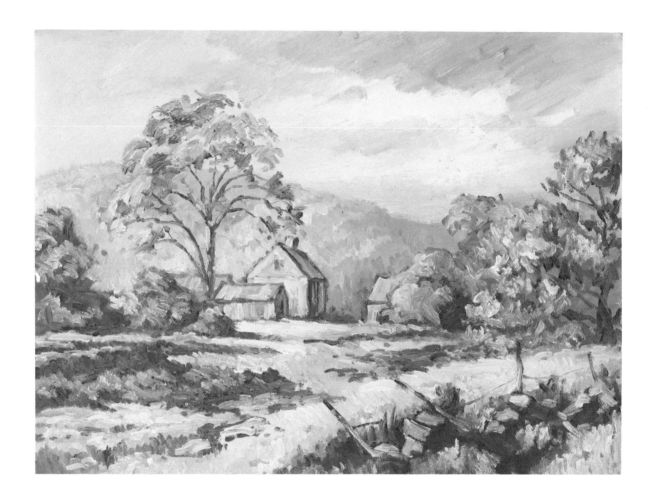

PROBLEM

In the constant search for interesting and different interpretations of subject matter, one that is so wonderfully helpful, yet often overlooked by the amateur painter, is the use of cloud shadows upon the earth. With the sun behind them, clouds actually cast huge shadows on the earth. They move by rather rapidly, however, and in brief periods of time they create some of the most wonderful effects of light and dark. Naturally, under these conditions, this fleeting effect has to be painted from memory. In this painting I have tried not to paint a deliberately bad rendition of the subject—but it is rather ordinary. The picture needs more drama, particularly at the center of interest, the house beneath the big tree. The pattern of lights and darks needs improvement too—there are lots of small lights and darks, but no really *big* masses of shadows to contrast with the lights. This is the sort of picture in which cloud shadows can make an enormous difference. Because such shadows might occur anywhere, you are free to decide where to place one to accent your composition. We are most conscious of cloud shadows when we are on a high hill looking down into the valley where we can see the cloud shadows traveling along the landscape. However, the effect I usually use is not one seen from a high vantage point, but rather right down in the area itself which is momentarily either in shadow or sunlight. Just a word of caution—because the clouds causing the shadows are quite high, these shadows should not have as sharp a transition from light to dark as those made by buildings.

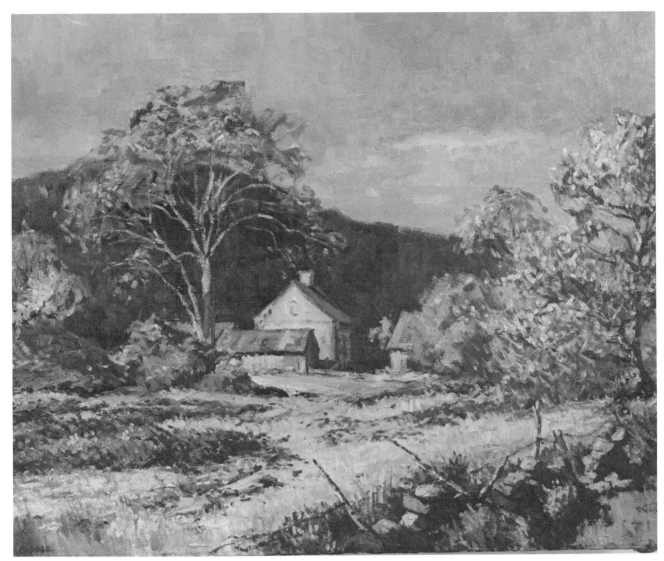

NEW ENGLAND MOTIF. *Oil on canvas, 24″ x 30″.*

SOLUTION

By selecting and remembering the precise moment when the sun hit the foreground and the middle distance and a huge cloud shadow appeared on the hill beyond, I've transformed this painting into a more dramatic composition. The dark background emphasizes the lights on the farmhouse and on the sheds; there are no competing lights around them, so they look brighter and more important. The problem painting has fairly strong contrasts of light and dark in the sky; here, I've minimized these contrasts and actually darkened the sky so it becomes less distracting, though it still suggests openings that would let the sun poke through. With the sky and hill darkened, I can now emphasize the beautiful lights on the magnificent, old elm that hovers over the farm like a mother hen. Cloud shadows are versatile; you can use them in exactly the opposite way by covering the foreground with a cloud shadow and bathing the middleground or the distance in light.

It might interest you to know that this is the same farm used in the following key. The longer you paint, the more you will find that there are many possibilities right in the same locale.

23. Emphasize the Foreground by Placing the Background in Cloud Shadows

PROBLEM

Here we have another demonstration of how helpful it is to throw a cloud shadow over part of the landscape. The mass of trees in the center of the painting contains a riotous array of autumn colors—yellows, reds, and oranges. The tree on the right side, next to the house, it also a brilliant gold; unfortunately this demonstration will be reproduced in black and white. I trust I have convinced you of the importance of achieving a value difference and not just relying on color alone. Here you can see that the trees do not register sufficiently against the light sky and the lights on the hills in the distance.

The trees on both the left and the right sides of the painting are too much the same size as objects near them. The trees on the left align with the hills beyond and the trees on the right coincide with the height of the house. The road was, as usual, tar, and the sky very ordinary when I was out there painting. The grass in the foreground is too general and monotonous—but the small panes of glass in the old windows have been overdone. This reiterates a point I have touched on before: the amateur lacks the knowledge to know what to give more attention to, and what to casually suggest.

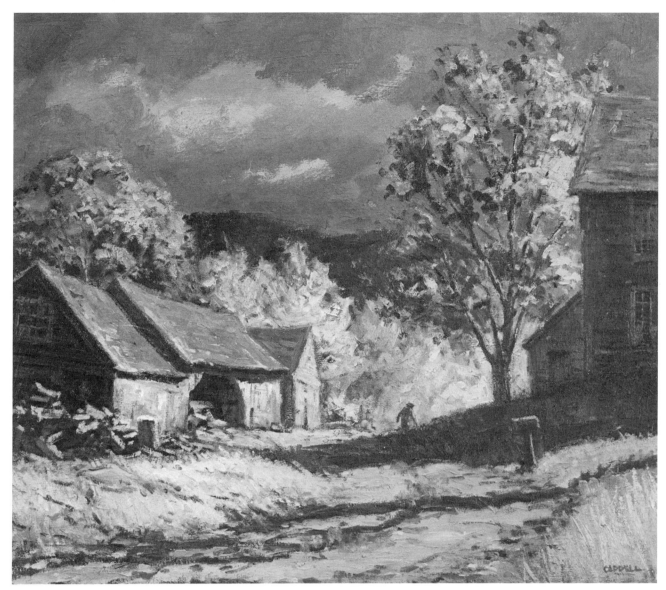

AUTUMN SPLENDOR. *Oil on canvas, 20″ x 24″.*

SOLUTION

This sky is purely out of my imagination; skies seldom happen exactly as you want them. It is not only more dramatic than the sky actually was, but it also gives us a darker value to play the trees against and a logical excuse to throw the distant hills into cloud shadows. Now the flaming trees have greater importance because they play against darks.

There are other improvements in the composition. I have heightened the trees on the right and left to avoid the unfortunate alignments mentioned in the problem. By converting the road to dirt, I gave it charm and character to go with the old farm buildings. I added the shadow in the foreground to complement the strong geometric patterns of the building and make the foreground more interesting. Notice not only the addition of a figure, but also the fact that you do not see any legs. This tells the viewer that the land dips down as it goes around the bend.

I mentioned before that this is the same farm group as in the previous demonstration. I have also used this very same group in the Key No. 1. For that painting, I stood farther to the left, on the opposite side of the road. This shows the endless possibilities of subjects and compositions in the same locale.

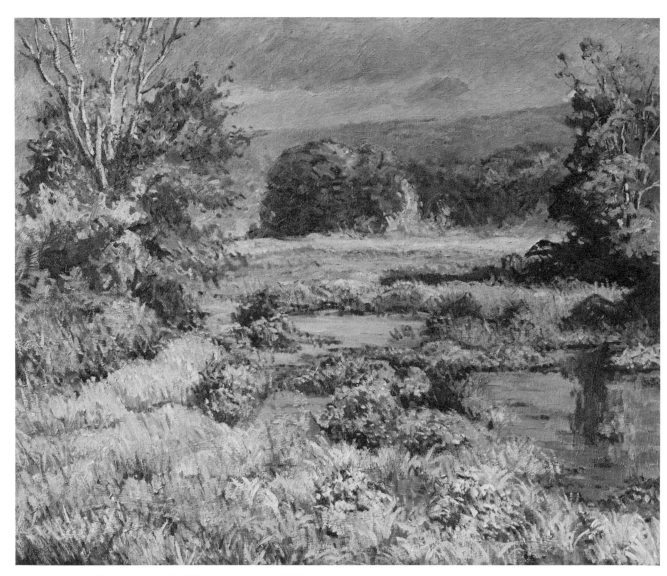

AUTUMN MOSAIC. *Oil on canvas, 24″ x 30″. Courtesy of Mrs. William E. Snyder.*

Color

Color as a subject is difficult to explain because it is so illusive. It is something that has to be "felt" to be understood. In drawing and values, we can be more specific, but unfortunately color is different.

Students often ask if I really see all the colors that I use in a painting, claiming they cannot. I reply with the statement attributed to Whistler when someone said they did not see all the colors used in the famous Nocturnes—"Don't you wish you did." I always explore every possibility for the use of lovely color, painting the subject in a more artistic and interesting way than it factually is—perhaps this can be compared to describing something in poetry rather than prose. Amateurs often paint less color than what is there; they usually do not see color and are hesitant to use it if they do see it. I embellish it!

In most amateur work, you do not really feel sunshine. Shadows are cool because they are illuminated by the secondary source of light, the blue sky, but sunshine is warm in color. Let me relate a charming story told to me years ago by a wonderful, old Italian painter by the name of Nunzio Vayana. This story has helped me to always remember that the sunlight in a painting should be painted warm and I hope the uniqueness of his description will help you to remember it also. With his delightful Italian accent he said, "The sun is like the woman. When the woman kiss you, she leaves the little lip rouge on your face. When the sun kisses the earth, it also leaves the lip rouge and everything is warm where she touches."

I have been greatly influenced by the Impressionists, because I feel their introduction of scintillating light and color is one of the most important advancements made in painting since the Renaissance. One caution, however: color is a marvelous thing, but it should always be accompanied with sound drawing and good values.

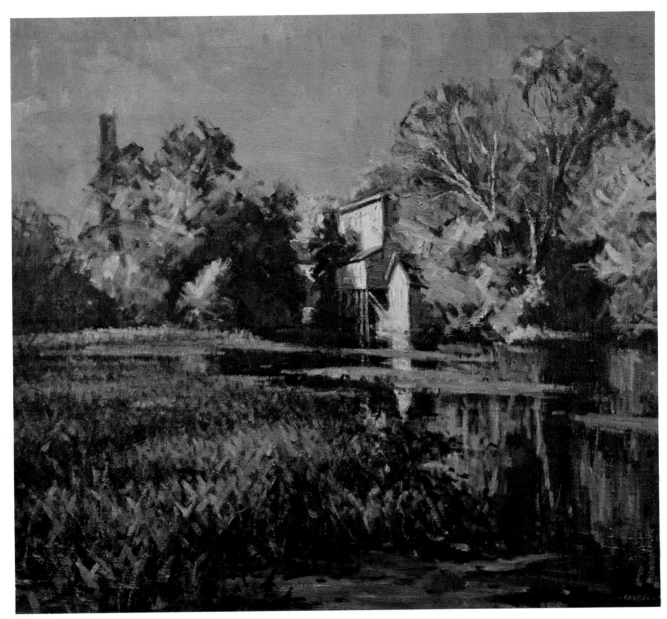

THE WHITE MILL. *Oil on canvas, 23½″ x 26½″.*

In explaining to new students in my class that I must first teach them to see, I often emphasize my point by remarking that I will teach them how to look for and see beautiful colors even in commonplace things. Here you can see how even scum and humble weeds can become a fascinating subject for the artist if he only senses their possibilities and uses them to advantage in his painting. I did not put an excessive amount of detail in the foreground, but gave it just enough attention to suggest pattern and color as the eye works its way into the painting. The sky was an ordinary blue but I lowered the value to keep the emphasis down in the painting. Notice how the colors of the weeds are re-peated in the sky, giving a sense of unity and charm to this area, yet still keeping it simple in design. The late afternoon sun gave me a chance to add warmth to the old buildings and I have taken advantage of some dead limbs and branches to bring relief to the overall green of the subject. The design of the pond lilies cutting across the reflection of the old mill with horizontal lines gives a sense of peacefulness. I doubt if any observer would question that this is a painting of a stream, but I would like to call your attention to the fact that not a bit of water is painted blue—it is all reflection.

24. Achieve Tonal Harmony by Departing from the Literal

PROBLEM

A painting must "hang together." This is a term that means little to the amateur for some time. There must be an over-all harmony of color even if we have to depart from the literal colors that are there to achieve it. Skies, like water, are often blue and so are thought of as always blue. In our efforts to paint an artistic interpretation, we must look for effects that are a bit different, rather than ordinary. The sky, as you can see, is painted blue, flat, and uninteresting, which is the amateur's usual answer to the problem. Because of this we lose a great deal of the feeling of a hot autumn day and the painting has no overall unity.

This painting obviously also suffers from poor design and the artist's lack of imagination. The composition is a symmetrical design with the spaces and shapes on either side of the barn too similar. The angle it was painted from places the cupola directly at the peak of the roof and misses the sunlight playing along the side of the barn. No attempt has been made to see and utilize the residue of old paint that usually remains on an old building up close to the overhang of the roof where it is more protected from the weather. The small tree lacks a feeling of form and the low bushes are much too uniform. The foreground field is completely lacking in character and texture, giving us another example of how the novice fails to exploit such an opportunity.

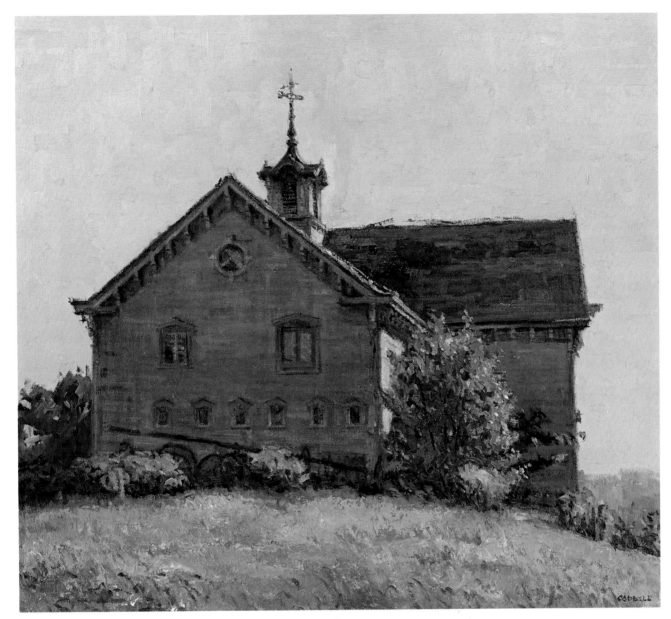

RURAL GOTHIC. *Oil on canvas, 23½″ x 26½″. Private collection.*

SOLUTION

Do you see how this rendition has a total harmony of warm tones that is achieved by painting a sky warmer than it actually was? At first, you do not even notice that the sky has been changed from the literal because the total effect is so gratifying. The luminosity of a hot, sultry, Indian summer day is now very evident. This effect has been achieved by using high-keyed yellow, pink, and blue in an impressionistic manner with the warm tones dominating. The sky harmonizes well with the warm autumn grasses and is a pleasing complement to the cooler variations in the old, weathered boards. Notice, too, the colorful accent provided by the old, rusted lightning rod running along the ridge of the roof. The suggestion of color found in the roof shingles and on the weathered boards up under the eaves

rounds out the overall tonal harmony. The use of this device is something that is gradually felt and utilized by the artist as he gains greater experience and maturity.

Regarding the design of the composition, notice how I have made the most of the sloping hill and changed the trees on either side for a less symmetrical solution. The foreground field has been developed so the viewer "feels" the texture of the grass and weeds. Of great help now is a point of observation that throws the cupola off-center and allows us to see more of its interesting design. This vantage point also gives us a small portion of the barn bathed in sunlight. Knowing just what detail to go after, and when, is something that comes only with years of experience.

25. Perceive the Colors in White Snow

PROBLEM

Here is another example of what we think we know preventing us from painting in an artistic and interpretive way. After all, snow is "white"; we have known this since we were old enough to know what snow is, and this is how the student paints it. It takes a lot of creativity to see colors in snow. One reason for this is that most people do not go outdoors and paint from snow. They sit home where it is more comfortable and try to make it up, painting from photos. In this painting, not only is the snow too white, but the sky is filled with white clouds rivaling it for attention. In addition, there is little feeling of sunshine falling on the scene, which would provide warm lights and cool shadows

in the snow. The time of day is when the sun hits the subject head on, diminishing any hope for snappy contrasts.

There are a few other typical amateur's mistakes in this painting. The stone wall is monotonous and unfortunately ends in the corner of the painting. Invariably, students have to show us that there are many individual stones in a wall and usually they are all painted the same size. The trees in the distance are painted as a solid mass, with no feeling that we can move through them to another plane, and they are overstated on the bank to the left. Once again we have a rather bad interpretation of a charming spot, mainly because the student did not know how to think.

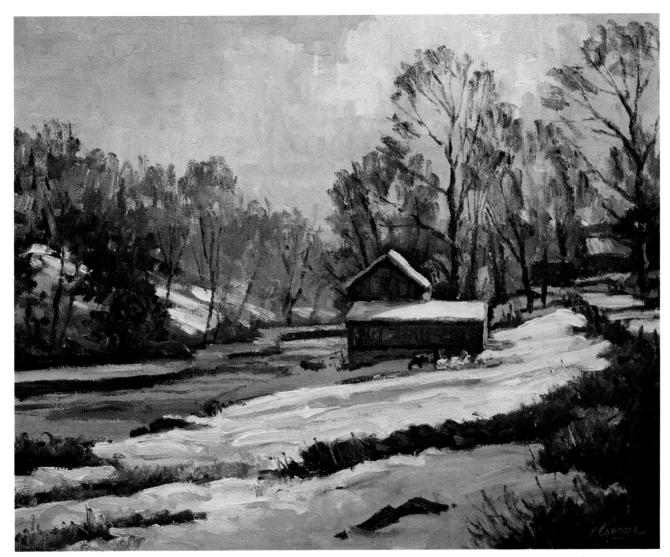

Winter at Clark's Falls. *Oil on canvas, 16″ x 20″.*

SOLUTION

Many colors can be found in snow; you will notice there is not one spot in the painting above that is just white. This, like all my paintings, was done on the location, even though the temperature was just 20°. It is the only way to get the real feel of it. Notice the blues and purples in the foreground shadows and the yellows and pinks in the highlights.

Vibrant color can also be seen in the other elements of this snow scene. The bare trees can be interpreted with lovely color and painted so that we sense a distance beyond them; compare this treatment to the solid statement "trees" opposite. The sunlight hitting the dead oak leaves is really quite brilliant because of the absence of more intense color. Even the ice has color as we note a bit of yel-

low ochre in the gray. The winter sun hangs low in the sky, casting long shadow patterns which extend out over the ice. The stream was actually all frozen over, as in the demonstration opposite, but I felt that showing water in the channel would make it more interesting. The foreground grasses and bushes gave me a chance to introduce more color which I repeated in the sky. I played the clouds down so they would not rival the importance of the snow.

The design in both these paintings is very much alike because I am concentrating on color in this key, but I call your attention to one point: I made the foreground field larger below the wall and smaller beyond it. Whenever we can diminish sizes, we aid the feeling of depth and distance.

26. Achieve Harmonious Color through Restraint

PROBLEM

Here in New England, the spectacle of color that nature gives us each autumn is unbelievable to those who have not witnessed it. It is brilliant beyond belief—the colors are dazzling—but somehow, nature is always harmonious, never harsh. I believe there are more bad paintings made in the fall than any other season. Perhaps the colors then provide a greater opportunity for the amateur to show his lack of color sense, taste, and selection. One rule might be—do not give the viewer too much. Do not have every tree screaming for attention as we have here. Some trees that are still mostly green, with only a hint of color, should be left that way for relief.

In their effort to get colors, many students forget values as we see here. Rather than modeling form with darks and lights, the student will resort to outlining the house to achieve definition. The road was tarred but I seldom find this as interesting as one changed to dirt. The sky is a flat blue. The tree shapes are repetitious and uninteresting. Notice in particular the four orange trees in the distance—they line up like a pan of biscuits. Not enough thought was given to the design of the red tree on the right. Its round, symmetrical shape is repeated in the yellow tree next to it and again in the distant orange one.

AUTUMN PATTERNS. *Oil on canvas, 23½" x 26½".*

SOLUTION

It is hard to describe in words, but a good painting should "hang together" with a color harmony that unites it and integrates the whole. In this painting there is a bit of all colors all over the canvas, rather than large spots of color here and there. This is something you will gradually understand and use, and as you do, your work will look more professional. The quality of color is much more important than a lot of spotty bright colors. Actually the colors here are more subdued than on the opposite page, but they appear more luminous, richer, brighter, and the painting has the total harmony I mentioned. Because everything does not scream for attention, the places that do command your eye have importance without being forced. Notice that I have

not hesitated in keeping trees that were only tinged with other colors mostly green, for in this way they become a subdued complement to the ones that are brilliant. I also diversified the shapes of the trees and carefully planned darks against lights rather than color against color.

One of the big differences I made here was the use of artistic license that I have mentioned in other keys—the introduction of trees that were out of the picture to the left. By bringing them closer and into the painting, I not only balanced the composition but found a logical excuse to play tree shadows over the foreground. This, along with changing the road to dirt, enabled me to get better color and design than actually was there.

27. Create Atmospheric Distance by the Use of Color

PROBLEM

One of the greatest problems in painting is how to achieve the feeling of space and air—better known as aerial perspective. It is only an illusion, but if handled properly, the viewer is convinced he can travel into your painting—that it is really not just a two-dimensional but a three-dimensional concept. The illusion is created with color and values; this key will deal mainly with color. Changes in value and color are caused by atmosphere—tiny molecules of moisture and dust suspended in the air—and the farther back in a painting we go, the more atmosphere there is between the object and the viewer. Now I know that some days are crystal clear with very little "atmosphere." On

these days, I draw upon my memory and experience to introduce greater differences in color and values than are visible. In this painting we can see how the lack of difference in color in the greens gives us a flat picture. The greens are practically the same value and color in the distance as they are in the foreground trees, and this leaves us with only linear perspective—the drawing—to show us that some things are farther back than others.

Notice, too, that the water, except for the wind ripples, is again an uninteresting blue. It should have been a reflection of the trees on the distant bank, but this would have made the water almost the same green, which would not have looked like "water" to the student.

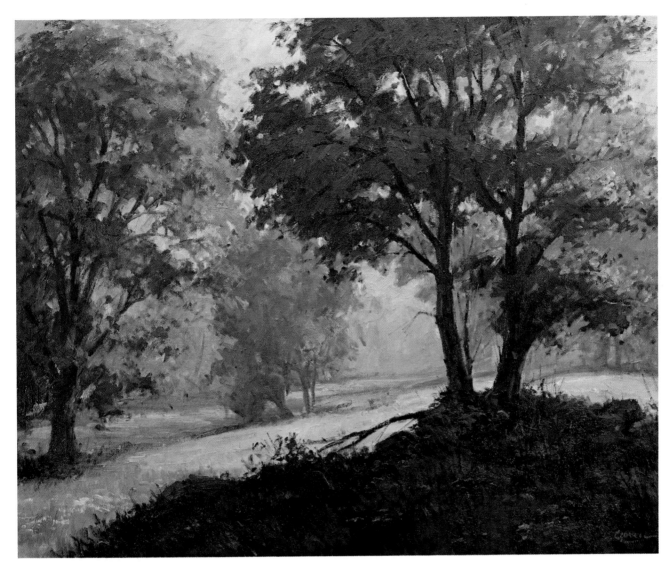

THE OLD MILL STREAM. *Oil on canvas, 24" x 30".*

SOLUTION

To create distance with color, you have to imagine very transparent layers of bluish gauze hanging in the air every 25 to 50 feet. This cuts down the intensity of both darks and lights the farther back we go, and gives the color a bluish cast. If there is enough red present in the trees, the distance becomes purplish rather than blue. This is a simple device but hard for the amateur painter to grasp and utilize. In this picture, I continued to paint the early morning haze that hovered about the stream, even after it had diminished by midday.

You will notice that there are four distinct planes in this painting: the foreground—the tree group on the right, the near middle distance—the tree on the left, the far middle distance—the trees in the center and the group behind the near trees on the right, and finally, the distance—the far bank beyond the stream. In each plane I have painted the shadow parts of the trees progressively lighter and more blue, and the lights progressively darker and less yellow. The tree patterns are now better designed to explain the form, and the heights of trees are diminished in each plane whenever possible to enhance distance. The foreground is entirely in shadow from an imaginary tree outside the picture. This simplifies the big pattern of light and darks and gives a greater feeling of luminosity within the composition. What light and atmosphere does to a subject is as important as the subject itself.

28. Introduce Warm Colors into a Summer Painting

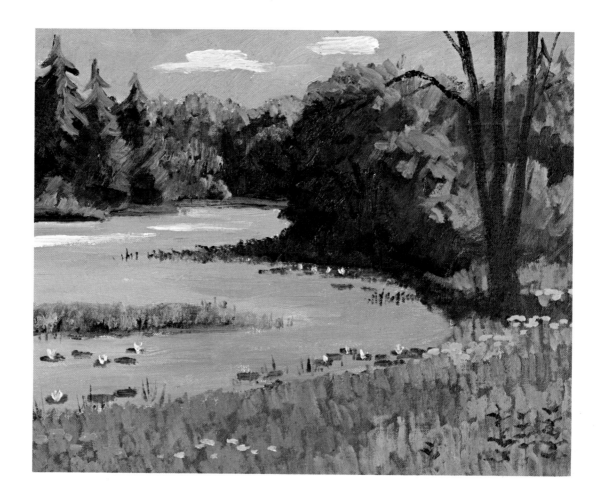

PROBLEM

Summer paintings are considered difficult because of the preponderance of greens present. There is not enough effort made to seek out and use warm colors whenever available. Here we have a prime example: the water. Because of various plant growth—algae, scum, pond lilies—the stream is really a beautiful tapestry of diversified colors. The average amateur is unable to cope with this intangible abstract design—mostly because he has not had enough still life training—so the mind reverts to a simple solution, saying this is water and water is "blue." It is also hard for the beginner to make the equally baffling category of weeds and grasses interesting. Like the water area, they are often left too simple, missing another opportunity of artistic expression. The attempt here to put some suggestion of detail into the foreground is spotty and uninteresting, as is the attempt to show pond lilies in the water. There should be lovely color in tree trunks but they are often painted a monotonous brown. The sky here is just blue, again missing an opportunity for warm tones in the clouds. Too often clouds are put in as white blobs because they are not thought of as having color. In the background there is no attempt to introduce atmospheric colors and play lights against darks to advantage. The trees are unfortunately nearly all the same height. You will see how I improve this on the opposite page.

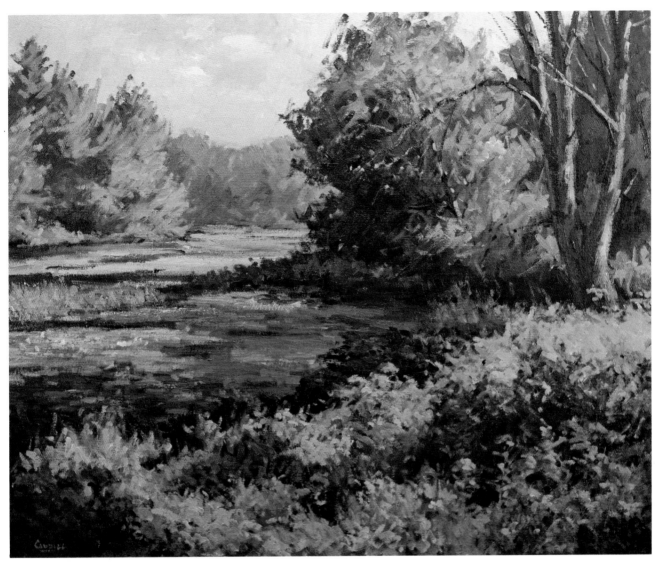

SUMMER TAPESTRY. *Oil on canvas, 24" x 30".*

SOLUTION

The important difference here is the absolutely fascinating colors one can find in water. There is really very little blue in this area, yet we recognize and accept it as water. The sky repeats the same warm colors and is lighter on the side that light is coming from. I darkened the foliage area behind the tree on the right which enabled me to play lovely warm lights and colors on the trunk. The foreground mosaic of weeds was actually out of the picture area, to my right, which I borrowed and painted into the foreground. These red weeds, called joe-pye weed, bloom in New England in late summer and are an artist's delight for the purpose we are discussing. Areas like this can be made as fasci-

nating as a tapestry if the artist is sensitive enough to utilize the colors and has the ability to cope with them.

Besides taking full advantage of the colors present in the scene, I eliminated the "flatness" that exists in the problem painting. For example, the trees in the middle distance have been heightened so that there is a definite diminishing of size in each plane as it goes back. I have also simplified the planes in the background and played light areas against dark areas so the form explains itself better. The blue haze one finds in the early morning atmosphere is a help and should be always employed to enhance the feeling of space and distance.

29. Paint Moonlights with More Colors than Blue

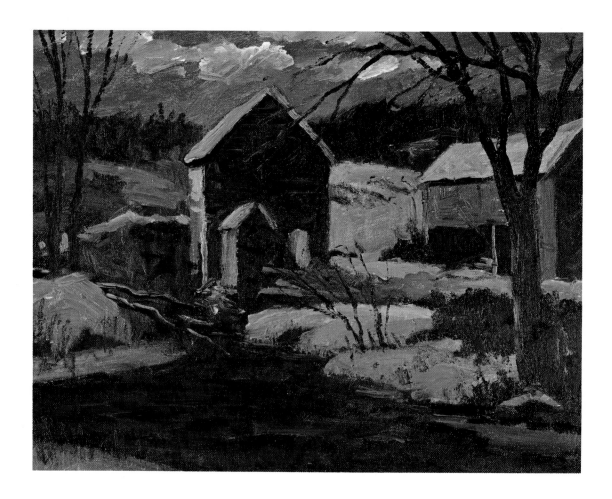

PROBLEM

As you know, I am a great advocate of painting directly from nature, but obviously a moonlight scene has to be a studio project. Many times I suggest that my students, as a home assignment, try painting a moonlight version of one of their landscapes. The most common mistakes made are painting primarily in variations of blue and failing to get enough luminosity. It takes a great deal of feeling and artistic interpretation to get away from these pitfalls, and you can see how the picture above suffers because of them. The only variation from the blues has been a limited use of umbers and siennas.

In addition to its color problems, this moonlight con-

tains several other errors. Drawn by the lights played up in the clouds, your eye travels to the top of the painting; the lights used here should have been used instead on the foreground snow. The darks of the distant trees are much too dark, consequently eliminating any feeling of space and depth. The bushes that offered an opportunity to introduce color are painted a dark, muddy value instead. Note that in the painting opposite, I have not changed the composition very much. I wanted to demonstrate what changes in color and value could do for the same design. The added illumination gave me an opportunity to work greater detail into the water, with directional lines of the current leading into the center of interest.

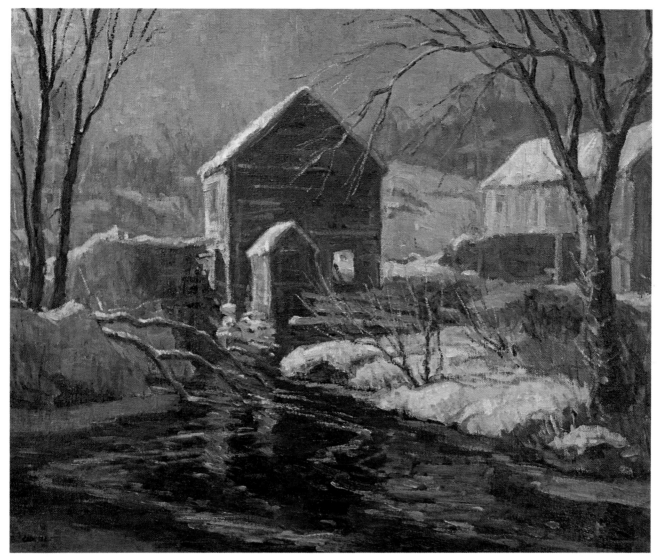

WINTER NOCTURNE. *Oil on canvas, 24" x 30".*

SOLUTION

This painting contains the two missing ingredients in the painting opposite—color and luminosity. We now know and feel *where* the light is coming from in the sky without it rivaling the foreground. The main improvement is getting away from seeing a moonlight as stages of blue. See how I have introduced color into the grasses and bushes. The light sides of the buildings have more color, yet are still restrained. Even the snow has soft variations of colors other than blue in it. I have also handled the water area with more color and detail. All this is helped and made possible by a greater sense of luminosity in the overall concept. With more light present, we can "see" more colors. Since the object of making a painting is to convey an artis-

tic interpretation of the subject, seeing and feeling as much color as possible cannot be emphasized too much.

The changes in value make a big difference in the painting. Note the feeling of atmosphere now in the darks of the painting, and as a consequence of this, the greater feeling of distance. To point out in particular—the darks of the foreground tree on the right are darker than the dark area under the barn directly behind it. This progressive lightening of darks takes place once again in the distant trees behind the barn, which are another step lighter. Now the foreground tree registers against the distant trees. The very same progression of values that takes place in the daytime should be used in moonlight.

30. Observe More Colors than Blue in Water

PROBLEM

One of the greatest examples of how the subconscious mind dominates our analytical perception is how we see water. If you ask the average person what color water is, he will invariably say blue, and this is the way most amateurs paint it. For the same reason, skies are often painted an uninteresting, flat blue. Actually, water has little if any color. We think of it as blue because it often reflects a blue sky. Water acts as a mirror and the sharpness of the reflections on it is governed by the degree of agitation. Wind ripples—tiny waves caused in the water by the wind—are lighter than the surrounding reflections because they reflect light from the sky above. In this demonstration we have a classic example of the mind telling us that the answer to painting water is blue. If a person has not had

enough training to enable him to see values and colors in very undefined, subtle patterns, he invariably resorts to this cliché.

Notice also that the distance is too similar in color and value to the foreground trees that are superimposed over it. These same foreground trees are poorly designed, too evenly spaced. The pine tree in the upper right has a repetitious saw-tooth edge. In painting birch trees, one has to be careful of the corny overstatement that causes some representational painting to be regarded with disfavor. The attempt in the foreground to say pond-lilies is contrived in placement and handling, and the right foreground—which should not come exactly to the center—has not been given enough sensitive detail.

SUMMER REFLECTIONS. *Oil on canvas, 24″ x 30″.*

SOLUTION

There are absolutely beautiful patterns and colors in water if you know what to look for and how to see it. The weeds, algae, scum, and plants offer wonderful chances for color supplements such as in the yellow growth on the left and purple pickerelweed in the far right. I usually paint water slightly agitated so the mirror reflection is not as sharp as the image above it. Wind ripples can have color, if we have color in the sky above to justify it. Here we have a cold pink with a light cerulean blue painted into it to give us a neutral unobtainable in any other way.

The early morning haze gave me a chance to use more atmospheric colors in the distance, as well as an opportunity to actually show the rays of sunlight. I have played light foliage in the distant plane against the pine tree on the right. Note also the varied edges of the pine silhouette. Every opportunity should be used to introduce warm colors into a green painting. I have dealt with this more in Key No. 28, but I do want to call your attention to this additional example in the island on the left. The birches mentioned in the problem are here also, but handled softly so that they fit in unobtrusively. Notice also how the ones on the left side are made just a bit higher than the mass of trees behind them. The greater detail in the right foreground, in contrast to the only suggested detail in the distance, is always recommended to help the illusion of depth.

31. Paint Cool Shadows to Make Sunshine Sparkle

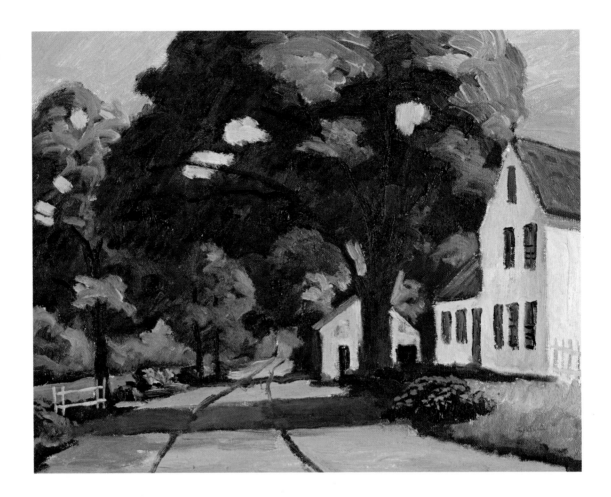

PROBLEM

Most amateurs are not only timid in painting the contrast of sunshine, but they do not paint it warm enough. Everything the sun hits becomes lighter and warmer in tonality—the shadow areas that the sun does not hit are illuminated from the sky and are definitely cool. Cool areas adjacent to warm ones make the warms look even warmer. It is the basic theory of accentuation by use of complementary color. Here we see a murky, yellow-brown color for the shadows on the road; this is the solution most students use. In addition, the shadows are so hard and uniform and the suggestion of wheel ruts so overdone that they resemble streetcar tracks. The shadow side of the white house is, of course, not sufficently dark—no effort was made to find cool colors

in it. For some reason, very deep-seated in our subconscious, a white house is white even on its shadow side. It takes years of training to get some people to paint it otherwise.

Let me point out some other typical mistakes that students make. The tree shapes are too solid and rigid—edges should be soft enough so that we feel the tree moving in the breeze. The sky holes are repetitious in size, hard in delineation, and too bright. The trunks are just brown with no attempt to find interesting variations. One must be careful in handling the colors in bushes and flowers. Unless this is done skillfully and tastefully, your painting becomes "pretty" rather than artistic.

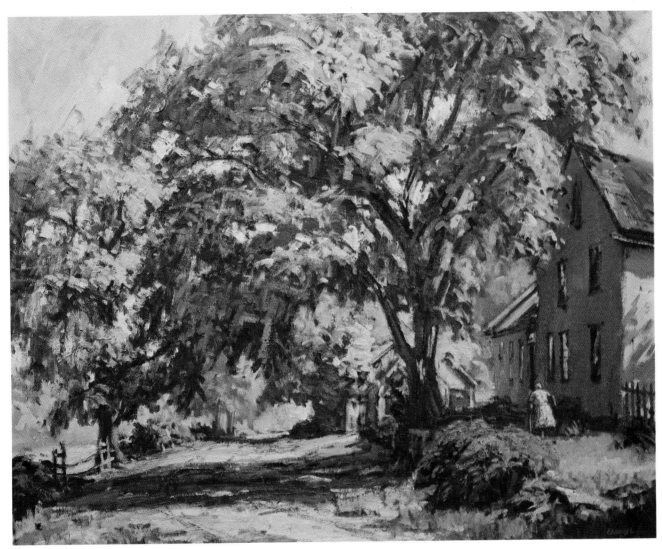

THE JOHNSON PLACE. *Oil on canvas, 24″ x 30″.*

SOLUTION

I have already explained the theory behind our use of cool shadows—here you can see the results of its application. One learns to handle every passage of a painting with as much artistic charm as possible. Notice first that the shadows of the road are soft and decorative. My approach is to paint them initially with cool variations of blues and purples. Then, while this is wet, I work warm earths into it, getting a delightful combination of both. Let us turn our attention next to the large white farmhouse. The shadow side is now actually darker than the roof. I first painted it with cool grays, then I tried to find other colors that influenced it and painted them into it. I utilized a tree shadow on the light side. Because it is painted in cool colors it makes the sunshine sparkle, and you will notice the

design of the shadow points *toward* the sun as we discussed in Key No. 33.

A general theme I continually touch on is the great variety of possible solutions to similar problems that can be used rather than relying on ordinary, repetitious ones. Notice the windows of the old farmhouse. Each one is a slightly different pattern of colors and values—most students paint windows all alike. Another point to call to your attention here is the atmospheric handling of the trees, with the shadow portions in particular getting bluer and hazier as they recede. Notice the artistic and poetic use of warm colors throughout—the sky, the road, and the grass. Handled in this way, flowers take their proper place and we are not unduly conscious of their spotty colors.

32. Perceive the Colors in White Clouds

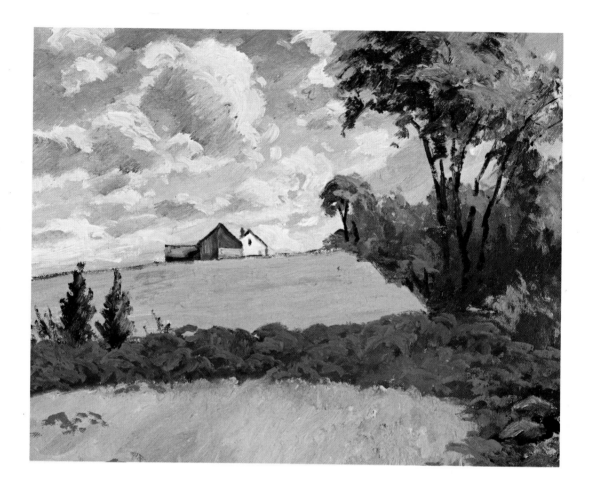

PROBLEM

When students first start to paint clouds, they usually paint them all white. Even after they start painting parts of the clouds in shadows, they continue to paint the highlights white. In this key I hope to break you of this habit. Here you can see that the whites in the clouds are so chalky that they rival the white farmhouse on the horizon. A line had to be used to define the house and keep it from blending into the sky. In addition, the sky is overplayed and attracts too much attention away from the rest of the painting. You cannot always paint things just the way they are; you must be selective, as demonstrated in the painting on the opposite page.

Let me point out other mistakes that exist in this paint-

ing. The whole foreground should have been handled with a greater sense of design. The red sumac bushes are monotonous in the repetition of their color and design, and become a barrier preventing the eye from traveling up the hill to the farm group. The two hemlock trees on the left are not only too identical in size—unfortunately ending just on the horizon line—but also are not large enough to balance the weight of the right side of the composition. The lower right corner of the painting is poorly resolved, making a continuous line with the bushes running up and over the hill. The foreground should have been handled more sensitively with detail to enhance the feeling of depth.

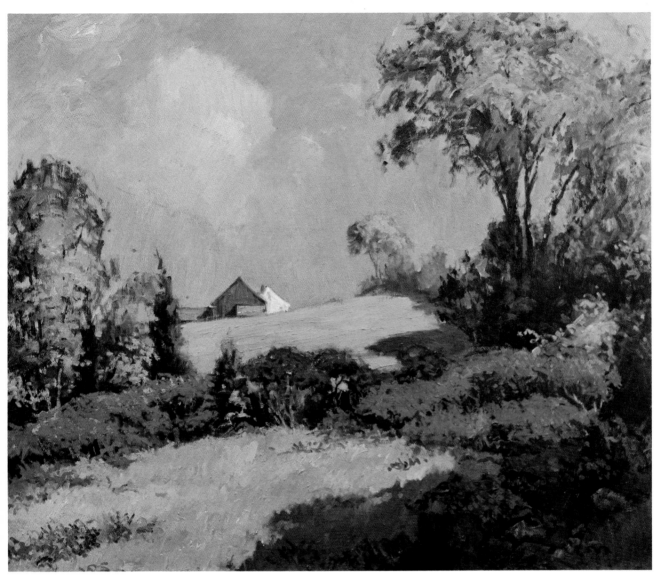

GARDENER'S HILL. *Oil on canvas, 30″ x 36″.*

SOLUTION

I don't think anyone would question or doubt the impression that there are large, billowy cumulus clouds in this painting, and I have done it all without going to the high-keyed white so often employed. To point this out further, notice how I have the white farmhouse standing out unrivaled by the sky full of billowy clouds. Not only are the clouds restrained in value, but observe the lovely colors that are used in them. Notice, too, that the colors in the rest of the painting (reds, yellows, and greens) are repeated in the sky in a muted fashion.

I have made some other improvements in this painting. For example, the sumac bushes are now placed so that the upper field is smaller in size than the lower one, enhancing the effect of distance. There is a much better design to the entire foreground. I have used a cast shadow over the center of the sumac, from the big elm on the right, to break up the pattern. The elimination of the barrier effect mentioned before now allows the eye to travel quite easily into the painting. The bushes themselves have a greater feeling of detail as we sense them growing on stalks. I moved the remains of an old stone wall farther into the composition, and threw this lower right-hand corner into a shadow from a possible tree outside the painting. An interesting group of trees down the hill to the left was brought up into the picture and helps tremendously to balance the heavier right side of the composition.

33. Make Patterns of Sunlight on Buildings Point toward the Sun

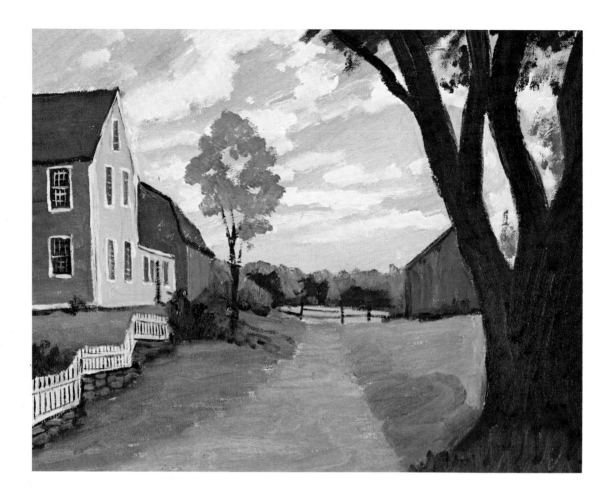

PROBLEM

In Key No. 18 we discussed the importance of using decorative shadow patterns. In this key, I want you to notice how in a decorative pattern the design of lights and darks on uprights tends to point toward the source of light—the sun. This painting shows a total disregard for the possibilities of shadows flowing over the landscape. Students find this so confusing, because it constantly changes, that it is usually ignored. Without the cast shadow to soften it, the road is much too prominent and symmetrical.

Let me point out some other typical mistakes. An amateur, faced with a large tree such as the one on the right, can become so impressed by its size that he makes it too large in proportion to the rest of the composition. Notice that the one in the solution painting opposite is actually smaller but looks larger. The sky is too busy, competing with the rest of the subject. Students have difficulty coping with the perspective in houses above eye level. They make the perspective angle too horizontal and not acute enough—notice the windows becoming too level. The barn did align with the house roof line, but should not have been painted so literally. And the distant trees align too evenly with the roof line of the barn. The novice artist painting a picket fence feels he must put in every picket. The white trim on the shadow side of the house is painted too light and the yellow is a most uninteresting color.

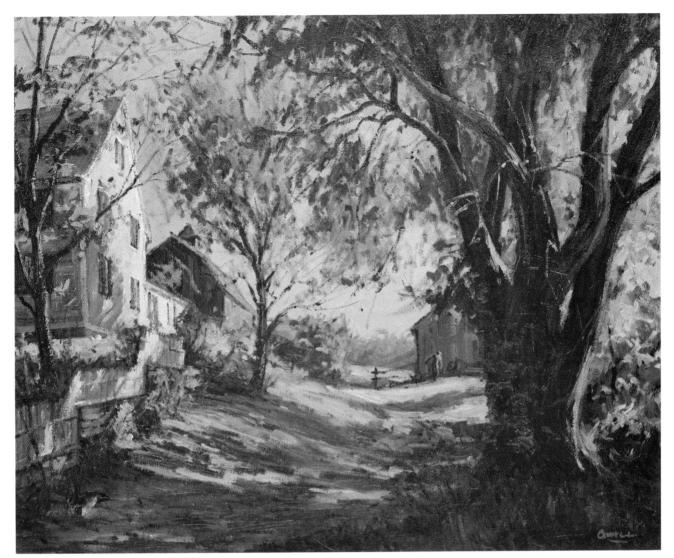

SUNSHINE AND SHADOWS. *Oil on canvas, 24″ x 30″. Courtesy of Mr. and Mrs. Wilfred Jodoin.*

SOLUTION

The main improvement I have introduced here is, of course, the decorative use of shadows traversing the road and climbing the fence and house. In doing this I must always be aware of the source of light. Notice that when the shadows fall over uprights, such as the fence and the house, there is a predominant angularity that points to the source of illumination—the sun. The orange tree in the center is now handled in a way that gives me an excuse to play a decorative shadow pattern over the geometrical structure of the house. We have no doubt that there is a picket fence leading into the composition from the left corner, but the play of lights *on* it is much more interesting than spelling out "pickets."

The tree on the right is still large but now gives me the space to play colorful foliage around it. Moving it into the painting throws the road off-center, and, of course, the cast shadow on the foreground eliminates the harsh lines of the road. The barn is moved away from its unfortunate alignment with the house, and the reds are weathered and more artistic. I have kept the sky simple so as not to compete with the decorative tree patterns playing against it. It also provides a foil for, and does not compete with, the lights on the yellow house. The distance is pushed back with atmospheric values and color, and the introduction of the little figure heading out to the barn to do the chores adds that touch of human interest I deal with in Key No. 11.

34. Exploit Wind Ripples on Water

PROBLEM

Ponds usually have a calm, placid look. This is brought about by the use of horizontal lines in the composition, and wind ripples are a great device if you know how to use them. Wind ripples are actually just what the name implies—the wind skimming over the surface of the water causes little ripples or waves which break the mirror image and reflect instead light from the sky above. There is no positive law of nature that wind ripples must conform to, so their use as a design element is limited only to the artist's ingenuity. Most students either ignore their possibilities or use them crudely—as in this example.

Another very common mistake I must emphasize here is painting ponds too high up in the distance in an effort to make them recede. (This is also done with roads.) The composition above is bad because the angular lines of the water and treetops almost sweep us right out of the picture to the left. Notice the other opportunities missed in this picture. The trees are uniform in shape and lack modeling with light. The clouds are also uniform in size and shape, and are treated as white masses; if they contained some color, it could then be reflected in the water below, which would provide a unifying element. The reflections on the water's surface are too small; they should be the same size as the trees themselves.

AUTUMN SPLENDOR. *Oil on canvas, 24" x 30".*

SOLUTION

By utilizing the design of the wind ripples and incorporating in them the colors from the clouds above, we now have water that lies down and recedes. The design of the water takes us around the land masses and into the middle of the composition to the pond beyond rather than out of the composition as before. Notice how I reversed the line of the distant trees so it now brings us back into the composition rather than taking us out, and how I have carefully designed the trees so as to play lights against darks for modeling and registration. The tree shapes and colors are diversified, and as a consequence more interesting and artistic. We know there is a large pond around the bend in the center of the painting, yet it is not as high as the green grass area behind the large tree on the right. The reflections now more closely relate to the size of the trees, yet I have subordinated them with pond lilies, grasses, and of course the large design of wind ripples. The bold design of the wind ripples from right to left and back around the land to the center is aided by the skillful use of grasses and weeds in the foreground. I moved them from the right to the left and made more of them. The suggestion of detail compared to the broader handling beyond gives us a greater feeling of distance, yet is not carried so far that the viewer has difficulty getting over it and into the center of interest.

35. Darken the Adjacent Sky to Dramatize a Light Object

PROBLEM

Paint has a limited range of values. So, to make lights appear even lighter than they are, we lower the values adjacent to them and soft-pedal competition. It's amazing what this simple formula accomplishes, but it is seldom understood and used by students. In this demonstration we can see an example of not doing this. A white building never looks light against a light sky; here, a line had to be used to define the edge of the house.

Let me point out a few other common errors. The student often finds it difficult to paint the shadow side of white buildings sufficiently deep and rarely dares to splash a cast shadow of a tree up the sunny side. The white clouds offer unnecessary competition to the whites in the build-

ing, and of course they are much too repetitious in shape. The trees on the left side by the house are also too similar in shape and design. This idea of varying shapes and design seems to be very difficult for the student to grasp. Invariably, when the student paints a stone wall, the stones are much too uniform in shape and color. The road is an uninteresting tar color and its linear design takes our eye away from the house. We have a rather spotty composition with our eye hopping around and not really settling anywhere in particular. I have not made this composition radically different from the solution painting, but I strongly urge you to study how the subject has been helped, mostly with consideration of values.

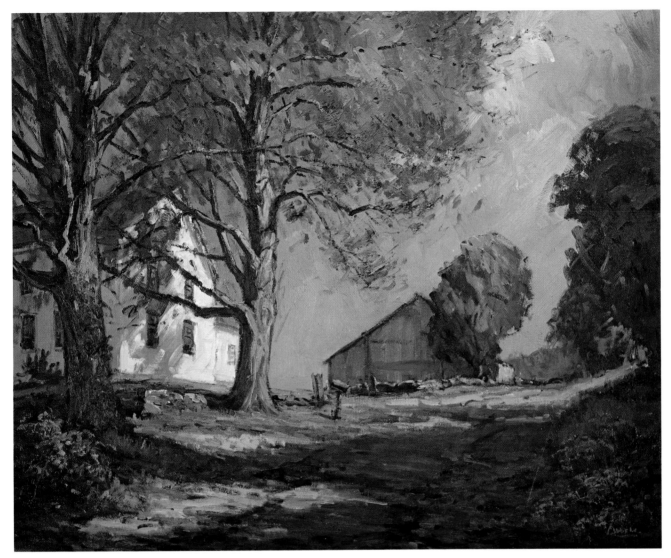

October Sunshine. *Oil on canvas, 24" x 30".*

SOLUTION

The most important interpretative change here was to not paint the sky literally, but instead to improvise one with a lower value. We still feel it is an autumn sky with cumulus clouds, but it now plays a subordinate role and the house is more brilliant because of it. Actually the light side of the house is almost the same value in both paintings, yet see how much brighter it looks here.

The next major move was to imagine some trees off to the right of the subject casting shadows across the road. This enabled me to change the road to a warm dirt color and still hold it down in value because of the shadows. The light that does play on it splashes out dramatically from the right and carries our eye over to the white house on the left. See how the shadow pattern across a road will modify the linear thrust of the road itself. The tree on the right was enlarged to bring it in front of the one by the barn. I used every means of making the two trees by the house different in shape and design, and concentrated on making the near one larger. I even varied the amount of sunlight falling on each tree trunk. The professional always tries to vary his solutions. The weeds that grow alongside the road have been developed and used in a decorative way. Even the fallen leaves scattered across the road and filling the wheel ruts adds charm. You just have to be imaginative enough to paint something in a more interesting way than it actually is.

36. Choose Backlighting for Dramatic Effects

PROBLEM

In this key I want to introduce you to the marvelous effects you can achieve with the use of *backlighting*, that is, light coming from behind the subject and silhouetting it. The painting above shows you how uninteresting the same subject would be with the exact opposite—*flat lighting*—which is light coming from behind the painter and falling on the subject at the same angle from which he is viewing it. Flat lighting is often used by amateurs but seldom by professional painters, because there is no light to model form and usually no pattern of light and dark, which is the core of a good painting regardless of subject matter.

I have kept additional problems to a minimum in this key, but let me point out that there is no feeling of spatial planes. Most students fail to use diminishing heights on trees to achieve distance. The trees here are too uniform in height—the near, middle distance, and distant trees are almost the same height across the top of the painting. The distance is all but lost as it merges with the row of pine trees in the middle distance. The marsh grass on the left is how the scene actually was and is too much the same size as the tree and rocks on the right. Wind ripples, although they did happen like this at times, are cutting the water area in an uninteresting way. From a design sense, we have too many horizontal lines going across our canvas.

MORNING MIST. *Oil on canvas, 24″ x 30″.*

SOLUTION

This early morning backlight, which lasted less than an hour each day and had to be painted mostly from memory, transforms an ordinary scene into one of theatrical drama. The luminous sky, which is a mixture of high-keyed primary colors, is reflected on the pond lilies, giving us an unusual center of interest and tonal climax as the lily pads shimmer against the dark reflections of the trees. The pads are handled by superimposing high-keyed cool lights over warm for maximum vibration. The sunrays penetrating the morning mist separate the distant and middle planes, and the tree masses are now interesting and varied silhouettes. Under these conditions, you will notice, the light hits only on tops and edges of masses.

I moved the marsh grass area on the left into the composition for better design, and the boat on the right is out of my own artistic imagination. It just seemed that anyone living in this beautiful spot would have to have a skiff tied by the stream—and it adds interest to the painting. The wind ripples have been kept to a minimum so as not to rob the pond lilies of the main attention. I have introduced individual grasses and lilies into the foreground. These are not so strong and important that the viewer has any problem getting over them to the center of interest beyond, but they do break up the water area. Also, by diminishing their detail the farther back in the painting we go, I use them to help enhance the feeling of depth in the painting.

37. Design Roads in an Interesting Way

PROBLEM

In general, amateur painters revert to symmetrical, uninteresting solutions to most problems, and roads are no exception. Here the road is in the exact center and the spaces on each side are almost equal. Also, for some unfathomable reason, in an effort to make roads "go back," the student often extends them too high in the picture. For esthetic reasons, and also as a way to introduce warm colors, I usually convert tar roads to dirt, but this necessitates knowledge and taste. The edges of a road without tar are soft, and the grass that often grows in the center is irregular—things students may not think of. The color improvised here is bad, and the design of the shadows rigid and parallel to the thrust of the road and bottom of the canvas.

Along with these main problems let me point out some other common mistakes. The sky is flat and just blue. There is not enough aerial perspective—notice that the distant hills and trees are painted the same color and value as the near ones. On the right side of the road, an exaggerated effort has been made to explain that these are "trees with trunks" rather than simply a pleasing abstract design that only happens to be trees. The stone wall and trees on the left are repetitious in shape and design. The usual problems of color in a summer picture exist here—a lack of colors other than green.

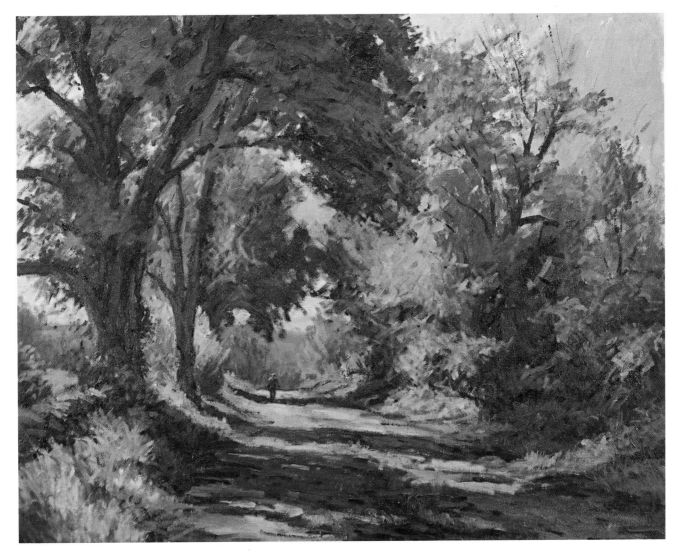

The Valley Road. *Oil on canvas, 24" x 30".*

SOLUTION

With the road off-center, I now have a much better design. Also, the shadows across the road have a pleasing diagonal thrust and the design of the road itself becomes subordinate to the decorative design of the shadows and lights running across it and over the adjacent foliage. There should always be a very positive design of lights and darks—but achieved in a soft way. The road is now actually lower than the field on the left, which is the way the scene really was. The indication of a figure walking in the road gives us a sense of scale and brings our eye into the center of interest.

The dark mass of foliage at the top now overlaps the light tree on the right rather than just touching it. I have painted the sky lighter near the horizon and to the left where the source of light is. Notice the colors other than blue in the sky. The distant trees and hills become an atmospheric blue-green because of haze, thus giving a greater feeling of depth. There is diversified color in the greens now. Note the color I have used in the grape vines on the right and in the dead leaves and debris that washes along the edges of the road. Notice, also, the beautiful blues and purples of the sky that are reflected in the shadows on the road. We must take every opportunity to see, feel, and use beautiful color.

38. Place Horizon above or below the Middle of the Picture

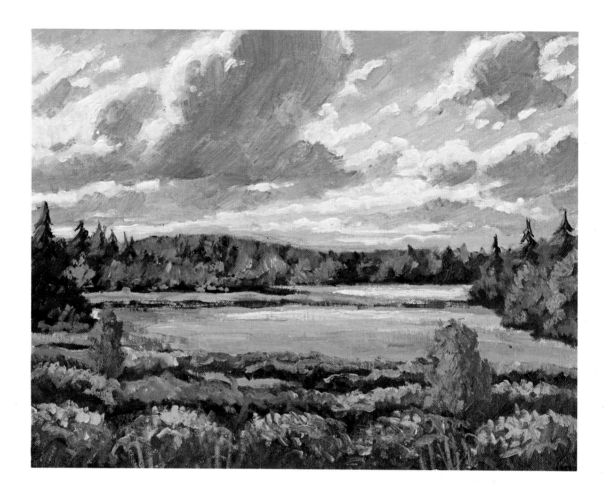

PROBLEM

One of the cardinal rules in painting is: do not put two pictures in the same painting. Compose your painting so that two areas will not compete with each other for the attention of the viewer. To accomplish this, avoid placing the horizon halfway up your canvas. Either lower it and give the sky more importance, or raise it and let the sky be subordinate to the landscape.

In this demonstration it is quite obvious that the sky and landscape fight each other. In fact every area of the painting is screaming, "Look at me, I'm important!" The colors in the background are just as bright as in the foreground, and there has been no diminution of darks to help the feeling of space and air. Quite honestly, anyone who would de-

sign the sky this well would do a better job designing the foreground, but I did want to take the opportunity to show you that when faced with a problem like this mass of bushes, the average student would tend to repeat shapes and colors. The two orange bushes in the foreground are too much the same color, shape, and placement, and the water is an uninteresting blue.

Another common mistake I would like to point out while we are on this picture is the tendency to stylize pine trees. This may be the result of seeing Christmas cards with trees whose tops resemble arrows pointing skyward. In reality, the branches at the top of a pine are lighter in weight and so grow upward, not down.

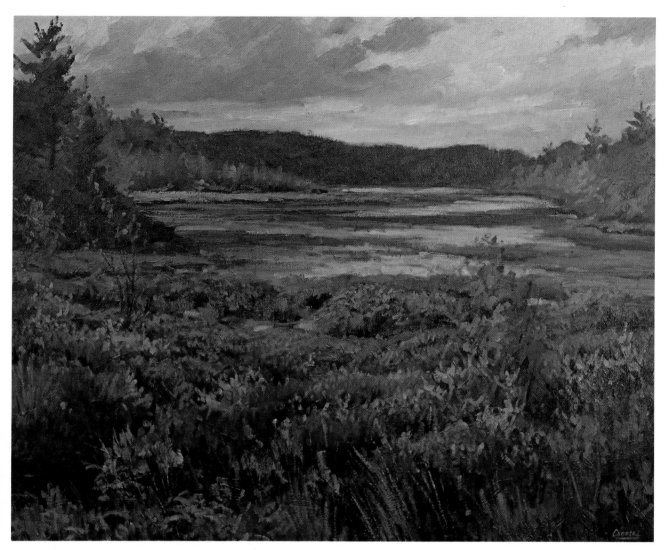

AUTUMN TAPESTRY. *Oil on canvas, 24" x 30".*

SOLUTION

You can see in this painting how the sky, even though interesting, plays a subordinate role to the landscape. There is no conflict of interest, as in the other painting, and it is better because of it. Notice how I have held the distance down in importance by placing it in a cloud shadow. In this way I have eliminated any lights back there that would conflict with the foreground. (I deal more with this device in Key No. 22.)

Marshes like this are difficult for the student, because there is no positive design to latch on to. You have to give a great deal of thought to the design element, playing darks against lights, avoiding repetition, and finding various textures, shapes, and patterns in what first looks like "a lot of bushes." If done properly, this can become as fascinating as an Oriental rug, but it does present one of the greatest challenges to the inexperienced painter. Note how the water can also become an interesting area if we selectively design reflectings, wind ripples, and marsh grasses.

The pine trees are not dark green but bluish, and they diminish in value with each successive step back. I save the darkest green for the depth in the foreground bushes. I have painted no lights in the sky to compete with the values in the foreground foliage, yet we know they are the cumulus clouds typical of an autumn day.

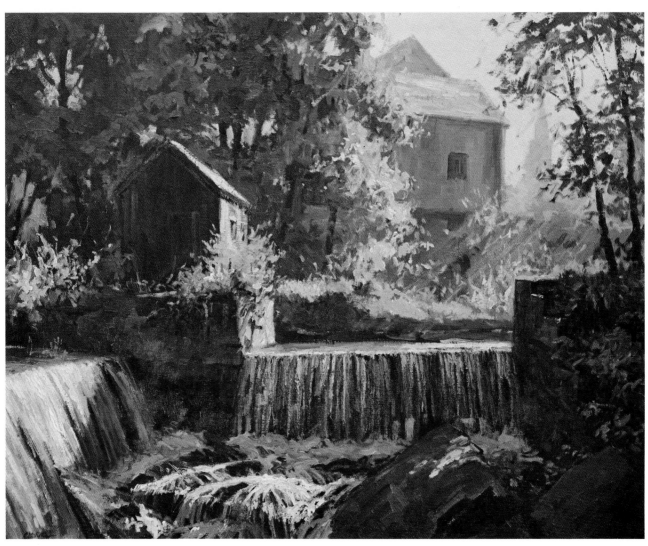

Morning Light. *Oil on canvas, 24″ x 30″. Courtesy of Mr. and Mrs. John W. Cullen.*

Space

Space in a painting is really an illusion, but if it is done correctly, the viewer will be convinced it exists because he *wants* it to. There are various things that the artist can do to help this illusion, and we shall go into them in detail in the following keys.

In painting space, the artist is actually just painting air. Of course, air in itself is quite invisible and what we are really dealing with are the molecules of dust and moisture in the air, which change the color and value of the objects viewed through it. You must learn to master both facets of the illusion of space—linear perspective and aerial perspective. I hope the following keys will help you to understand these important elements of painting.

An item in this category that the amateur gives little thought to is the part the frame plays in creating a total feeling of depth and space for a painting. A frame is a transitional as well as decorative item that actually separates reality from the illusion of reality. Because of this, a painting should never be viewed or displayed without a frame.

39. Diminish Sizes to Create Greater Depth

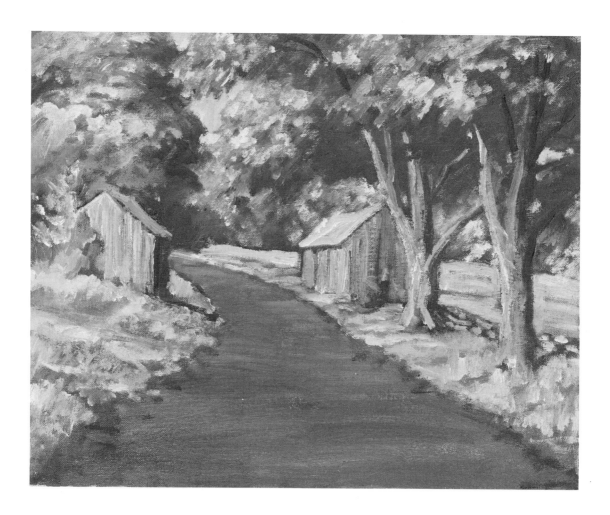

PROBLEM

It is said that no animal recognizes a painting as anything but a two dimensional object, in other words, just a canvas with paint on it. The human mind *wants* to be convinced it is seeing the "real thing"—a three-dimensional concept they can either pick up or walk into. We, as artists, must do everything we can to enhance this illusion of depth. One of the greatest devices is based on the simple principle of the railroad track—the farther back an object goes, the smaller it becomes. So elementary, yet not always utilized. It does not have to be just one object, such as the road here, but can be applied to a series of objects like the trees. The two trees on the right are very similar in size, even though one

is obviously closer to us than the other. The tree on the left behind the barn, which is the next step back in the painting, should dimish in size but is painted as tall as the foreground trees. The distant trees are so tall they merge in design with the ones in the foreground.

There are some other errors in this painting. The road is too symmetrical, coming out of each corner of the picture, and it has been drawn too high in an effort to make it go back (I discussed this in Key No. 37). Nothing has been done to relieve the uninteresting tar road. At the time of day selected to make this painting, the sun hit the subject from the front left, giving very little modeling to the objects.

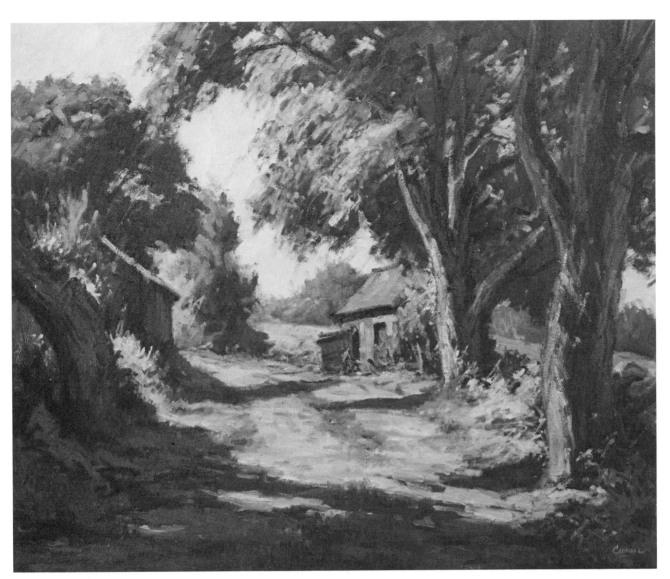

SHADY LANE. *Oil on canvas, 24" x 30".*

SOLUTION

The main difference between this painting and the one opposite is that the nearby trees have been enlarged and those farther back into the picture reduced. So simple, yet so effective. The near tree on the right was brought forward so that basically all we see is the large trunk—we are *under* its foliage. The next tree on the right is still a large tree, but it goes back because we see most of its foliage even though it goes out of the picture at the top. The next step back is the tree on the left, behind the barn, which is composed within the canvas. The tree in the next step back, to the right of the last tree and on the far side of the bend of the road is shorter still, and those across the field

complete five definite steps of progressive diminution. It cannot always be done this obviously but you can see how helpful it is when it can be used.

To balance the two trees on the right, I borrowed an old, broken, twisted trunk out of the picture and used it on the left. With increased size of the tree on the right, the road is not as perfectly symmetrical and it is softened by the play of cast shadows over it. Notice how this whole painting has been thought out to strategically play lights against darks, and how the design of the sky brings our eye down to the center of interest.

40. Diminish Values for a Feeling of Distance

PROBLEM

At the risk of being repetitious, let me say again—space and distance in a painting are purely an illusion. If the colors and values are handled correctly, the viewer is convinced that he can see great distances. This is accomplished by what we refer to as "aerial perspective," or the diminution of values on each receding plane. On some days we can see the effect of haze much more than on others. The farther back the area we are viewing, the more molecules of moisture and dust are between it and us, so consequently the value and colors change. The greatest stumbling block to teaching this to pupils is the fact that their mind "knows" the trees in the distance are the same color and value as the ones in the foreground, so they paint them that way. In the above painting it is only the drawing—linear perspective—that makes things recede; there is no evidence of diminishing values. Also, this painting has too much sky competing with the hills. The hills are not designed in an interesting way—they are repetitious and monotonous. The sky is another example of poor taste—the clouds are the same size and shape and detract from the main theme of "the rolling hills." There was no large tree in the foreground field, it was way off to my left, but see how in the painting on the opposite page its size and value helps to say "distance."

ROLLING HILLS. *Oil on canvas, 24" x 30".*

SOLUTION

In this painting there are five distinct planes: the foreground field; the tree area just beyond the lower meadow; the first rolling hill, which I have kept in a cloud shadow; the distant field and farm with the hill behind it; the last plane on either side of this last rolling hill. I have played cloud shadows over the near field and middle distant hill for variety of pattern and interest, but let us assume they were all equally illuminated. We would then have had the lightest lights and darkest darks in the near plane. With each succeeding plane that we stepped back, the darks would get lighter and the lights would get darker, until they met in the distance where there are no darks or lights

at all—just a middle value. You must learn this general principle and use it even on an extremely clear day when there is little evidence of it. Now, in this painting, the dark shadow values adhere to this formula, but the lights do not; as I said, I have eliminated sunlight in some areas for esthetic reasons. Notice how I have devoted more canvas space to the rolling hills and less to the sky. The sky, incidentally, did not look like this, but I designed it to substantiate the cloud pattern that I wanted to use on the land. See how I have made the sky interesting without competing—a principle I deal with in greater detail in Key No. 48.

41. Create Depth by Strengthening Foreground Detail

PROBLEM

Depth in a painting is purely an illusion—it actually does not exist but we want people to think that it does. To accomplish this we must do everything possible to help the cause and nothing to detract from it. In this key, I want to show you the importance of handling detail properly. Generally speaking, we use a greater amount of detail in the foreground and gradually lose it as we work back through the middle distance and distance. Here we can see that this concept has not been used and the painting has suffered because of it. There is no effort to utilize the beautiful patterns of weeds and grasses in the foreground. The distant hill has too much detail, causing a confused jumble of pattern with the middleground trees trying to register against it. In addition to these problems, the distant hill and the trees in the middleground are too much the same height. Furthermore, the hills and the stream are so designed that they take the viewer's eye right out of the left side of the picture—even the cloud line accentuates this.

QUIET BROOK. *Oil on canvas, 24″ x 30″. Courtesy of Dr. and Mrs. Albert G. Gosselin.*

SOLUTION

Here we see how the same picture is much improved by keeping the greatest amount of detail in the foreground and conversely simplifying the distance. You will find me referring many times to the tapestry of color and design you can find in weeds and grasses if you but look for it. Here they play against the dark reflections in the water. In the middle distance there is still detail, but not quite as much as in the foreground. Now, when we reach the background, we simplify. Notice how the trees in the middleground register against the background clearly—as darks and lights they register well against the soft middle tones of the distance.

I made some other slight improvements in this composi-

tion. The trees in the middleground are taller than the trees in the distant hill; this helps the illusion of depth, discussed in other keys. The group of saplings added on the left side of the composition keeps the viewer's eye from leaving the picture and turns attention back to the center of interest.

This is a very important key for you to remember. Unless there is some esthetic reason not to, concentrate on developing much more detail in the foreground of your painting and on gradually losing it as you go back through each successive plane. With the distance simplified and the foreground strengthened, you have a powerful tool to create the illusion of distance and space.

42. Maintain Distinct Spatial Planes

PROBLEM

This key is closely related to one of the most important aspects of landscape painting; that is, creating a convincing illusion of space and depth. In coping with this problem, we must try to break down the scene that we are trying to paint into distinct spatial planes: foreground, middleground, and distance. Sometimes there will be even more planes, with the middleground dividing into near and far middleground, or the distance having an additional hazy plane. Each plane must be completely thought out and organized with its proper set of values and colors or we end up with a jumble such as we have here. Faced with all the bushes and trees outdoors, students are often over-whelmed. The answer to their problem is to simplify and organize each plane. The solution may not always be as clear-cut as shown in this subject, but here at least you can see and understand the principle involved.

Let us discuss additional mistakes in this problem painting. The clouds in the sky are uninteresting in shape and attract too much attention. The tree line across the painting is uniform and uninteresting. The possibilities of the stream have not been realized; there could have been a beautiful pattern incorporating reflections, weeds, and wind ripples. The foreground has not been painted in sufficient detail and unfortunately comes exactly halfway across the painting.

SHIMMERING LIGHT. *Oil on canvas, 20″ x 24″.*

SOLUTION

This painting is not too different in composition from the problem painting, but see how it is organized into distinct planes and simplified into larger areas of lights and darks. The compositional changes consist mainly of bringing a tall pine tree into the picture on the left, and making the foreground cover three-quarters of the space at the bottom. Once we have thought out the subject into foreground, middleground, and distance, we begin to apply the additional principles we have learned to each plane. Primarily, the values and colors change in each plane as it goes back. In the foreground, we have the darkest darks and lightest lights under normal, equal illumination. As we progress back into each successive plane, the darks be-

come lighter and lights darker; also, we incorporate a bit of the atmospheric color change discussed in other keys. Now with the definite planes established, we treat detail differently in each: the foreground has a suggestion of a great deal of detail and we progressively lose it until the distance has very little. You may find times when these principles are not strictly adhered to for esthetic reasons, but the amateur should learn them and most of the time incorporate them in his work, as you see demonstrated here. In this painting the water is developed with more pattern and design, and in the sky we feel there are clouds without their attracting undue attention.

43. Try Placing the Focal Point in the Distance

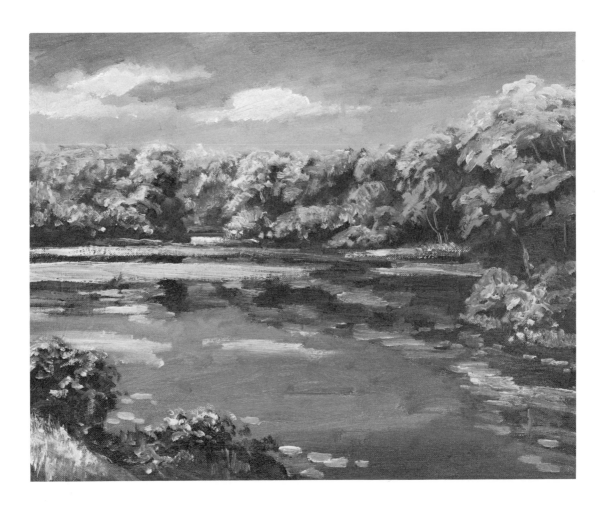

PROBLEM

So often we become repetitious in our solution to problems and this is one way to vary them a bit. Under normal lighting conditions we have lights and darks on the entire scene. The lightest lights and darkest darks should be in the foreground, and each should diminish in intensity as they go back in the various planes of the picture. In other words, as we go back into the picture, the darks get lighter and the lights get darker until they merge in some distant hills. Here the lights and darks are about the same all over. There should be four planes in this painting, but because the values are not used correctly, there is little feeling of distance.

This painting has other problems, too. The tops of the trees are too much the same height and flow too regularly from one to another. The sky is poorly designed and just manages to say clouds. The pond lily mass is one big glob and is not used decoratively. The foreground is not handled sensitively enough and fails to suggest more detail than in the distant planes. There is a general sweep of compositional lines from right to left and nothing has been introduced to stop the viewer's eye from going right out of the painting.

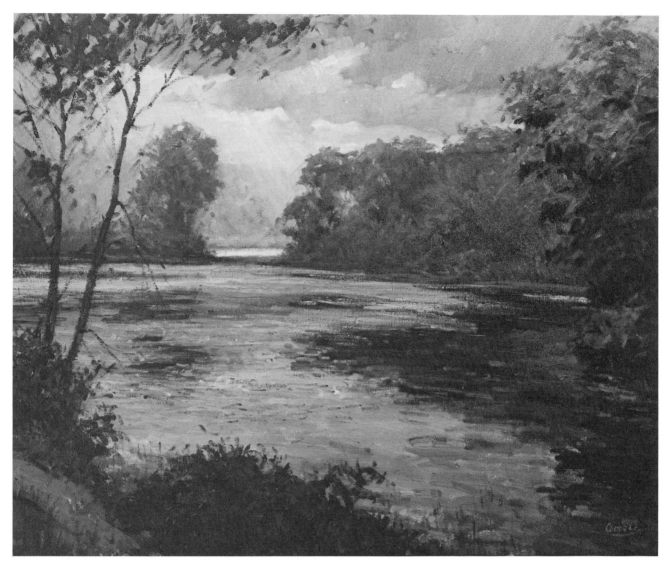

AFTER THE SHOWER. *Oil on canvas, 24" x 30".*

SOLUTION

The artist's job is to take an ordinary subject and render it in an extraordinary way—you can see that in this demonstration. To use the lightest light in the distance is rather revolutionary, but it can be done logically if we eliminate lights in the rest of the painting. The lighting effect you see here, which came and went in a few brief minutes, suggested a way to interpret this that took it out of the ordinary. The sun, just bursting through the clouds, is reflected on the distant lake. The clouds themselves are a purplish gray and provide a logical way to introduce colors other than blue in the water. There is a definite progression of values in the darks of each plane—see how they get lighter as we step back in the painting. Because there was no direct sunlight, there are no lights in these areas. The greatest way to emphasize the main light is to eliminate competition. The treetop line is much more interesting with a definite progression of heights as we step back. A pair of saplings was introduced on the left to prevent the eye from leaving the composition. I kept very little foliage at the lower section so as not to obscure the lovely distance. At the top of the trees the foliage becomes a dark silhouette, making the dark shadow portions of the clouds appear more luminous by contrast.

44. Keep Distant Water below Eye Level

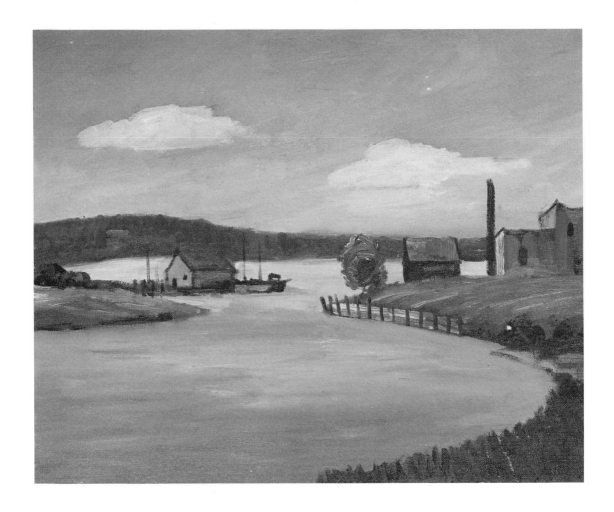

PROBLEM

When faced with the problem of a body of water in the distance—be it a cove, as in the above painting, or a lake—many students make the same mistake. For some reason, in their effort to make the water recede, they keep making it go higher on the canvas. If there were no buildings with perspective lines in the painting, this approach merely makes the body of water grow huge. The amateur just cannot seem to realize that the viewer is looking across the water, not down on it. If there are buildings present that show us where the eye level is, then the water looks as though it goes uphill at an angle, which, of course, is abso-

lutely impossible. I have seen this happen so often, and when I ask the student why, he explains that he is trying to make the water go back. This is simply the result of a lack of observation. We all know that water cannot flow higher than the eye level perspective line. Here again is a case in which what the student thinks he knows dominates his perception: he knew there was a large cove out beyond the shack and pier.

See if you can find the other mistakes I have incorporated in this painting. If you can begin to see them here, you should begin to see them in your own work.

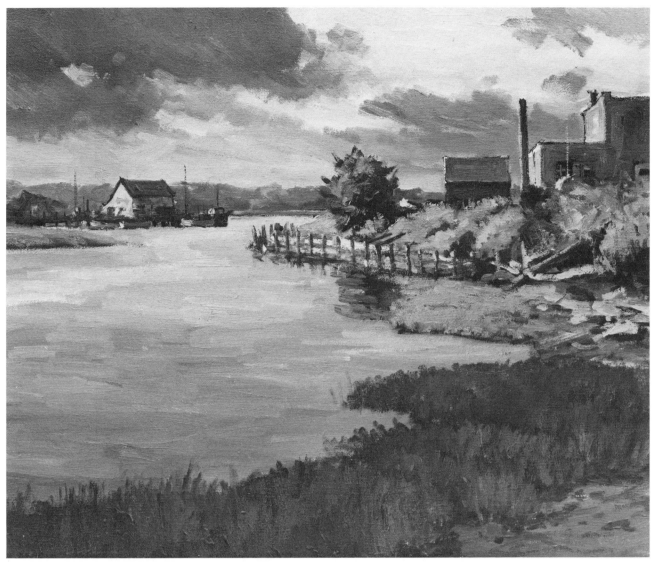

Wickford Cove. *Oil on canvas, 16″ x 20″.*

SOLUTION

I think this painting shows you the answer. Water just cannot go above eye level. We know that there is a large cove out beyond the buildings, but we have to remember we are looking at it from a low vantage point, and that it appears as merely a low, flat line under these circumstances.

While we are on this painting, let us go over other points that make it a successful and appealing canvas. First, the eye level was raised in the composition, giving us more foreground and less sky. The foreground grass is designed in a much more interesting way and handled more sensitively. It now enhances the directional thrust of the foreground water from left to right. I wanted an interesting early-evening sky that went well with the foreground yet did not compete with it. Notice how the clouds are designed so as to form a complementary opposing angle with the design of the water. The flotsam and jetsam that collects at the waterfront can become lovely passages of color and design—something that the novice often does not realize or know how to utilize.

This painting was very colorful because the source of light was the descending sun, but even so, the values must be right, and this is demonstrated in the black and white reproduction you see here. Like most of my paintings, this one was done right on location. In fact, it was done as a demonstration for a class I was teaching in the Narragansett Bay area.

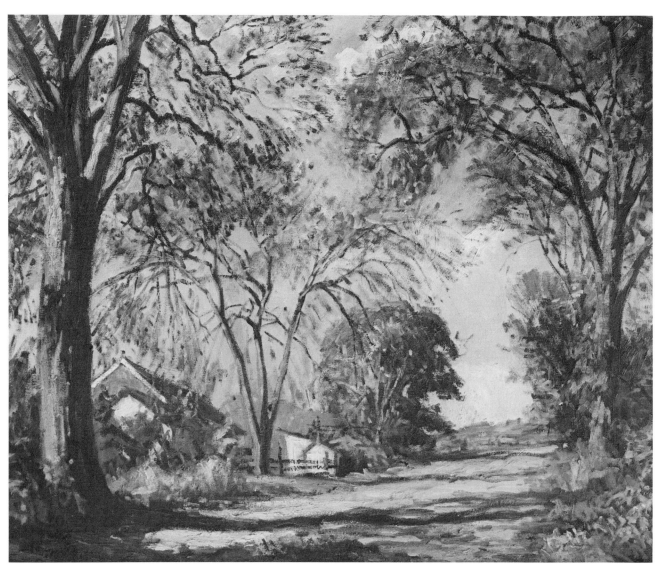

LACY ELMS. *Oil on canvas, 24" x 30".*

Trees

It is almost impossible to consider the subject of landscape painting and not devote some attention to trees. Students find trees difficult because of their loose, fluid shapes, and because most of the time trees are green, a hard color for them to paint. They are also overwhelmed by all of the thousands of leaves, until they learn to suggest broadly rather than paint details. Most of the amateur's problems with trees are due to drawing and design, and the answer is, as with most other problems, learn more about your subject. Study the characteristics of different species. Go out and see and be aware of their different forms. Be willing to make studies and sketches of individual trees rather than completed paintings, so that when you do put trees in your paintings you will do it more intelligently—they will look correct and be a thing of beauty.

There are many trees in the paintings in this book. Refer to them—study them—observe how they were painted. Try to define for yourself just what makes them look right. There is a lot to be said for developing the ability to "paint with your eyes," even when you are not actually painting. By this I mean the ability to study a painting and analyze just what the artist did, and why, to achieve the final effect that the painting as a whole conveys to you.

45. Make Tree Shapes Varied and Interesting

PROBLEM

It is hard to paint landscapes and not know how to deal with trees, yet this is one of the major stumbling blocks of the amateur painter. Probably because trees do not have positive shapes like buildings, the novice finds it hard to be specific about them. As a consequence, amateurs usually revert to using a very uninteresting, monotonous shape, and as we have found in other keys there is a great tendency to keep repeating these same shapes. For the most part, the solution ends up much too symmetrical, and I find myself referring to these trees in my teaching as "furry lollipops." If you have a few trees in your painting, you should deliberately try to vary their shapes and sizes, because if you don't, the chances are that you will tend to repeat shapes as in the demonstration above. Another comment I find I am frequently making to my students is, "Paint trees so the birds can fly through them." All too often their trees are much too solid and heavy. I always encourage my students to make studies of individual trees to become familiar with the great variety of shapes and designs. Once you have a thorough knowledge of trees, when you feature them in your paintings, they will take their place as things of graceful beauty.

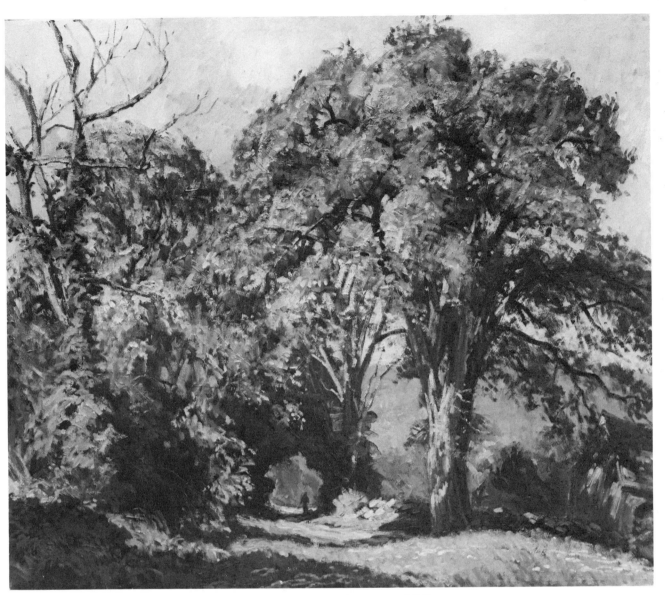

LANE TO THE HERMIT'S PLACE. *Oil on canvas, 30″ x 36″. Courtesy of Mr. and Mrs. Howard T. Brown.*

SOLUTION

Joyce Kilmer tells us in his poem set to music that "only God can make a tree," but with the proper sensitivity the artist can render them. To achieve definite shapes and patterns in a soft, flowing way—so that we almost feel the trees moving in the breeze—is not easy. It requires years of study and practice. The masses, patterns, and colors in a subject like this are really an intriguing abstract design. It takes experience before the student realizes this, and the secondary fact that the design only happens to be trees.

Notice the other changes I made in the composition. Although this particular scene was in reality a junction of two farm roads, I eliminated the one coming directly toward us. This left only the road coming in from the right by the barn and going down into the valley, where we see the small figure walking. Notice also how the foreground

design is now broken up by a cast shadow from a tree out of the picture to our left, and how the trunk of the tree on the right has become a lovely pattern of sunshine and shadow caused by the overhanging leaves. I try to make my trees varied in height and design whenever possible. Notice the dead tree on the left with the poison ivy vine climbing the gnarled branches contrasting the big leafy elm.

I like nothing better than to go to nature and make studies like this, which was painted entirely on the spot. Do not sit home and make up your trees from memory or photos. Get out in the field and *paint*. Nothing replaces being in first-hand communication with the real thing. Gradually you will understand your subject and paint it with the skill and sensitivity it deserves.

46. Relate Tree Trunks and Branches to Whole Tree

PROBLEM

Second only to designing trees as symmetrical lollipops is the tendency to make trunk and branches much too heavy in relation to the tree as a whole. Students are so impressed by a large tree trunk (especially if they walk over near it and relate it to the size of their bodies), that they usually overdo it in their painting, as you see here. The trunk of the big elm on the right has grown to almost half the width of the large farmhouse behind it! Now, regarding branches, they are either made to diminish too fast as they go up the tree or they don't diminish enough at the ends.

Hardly a day goes by when I have a class outdoors that I do not have to remind someone, "Remember, those branches have to turn into twigs by the time they get to the outer edge of the tree." This is just common sense and logic, but it is hard for a novice to cope with everything at once. When students do not go to the one extreme of painting trees too solid, they usually go to the other extreme of painting leaves by dabbing on spots that are heavy-handed and repetitious—like leopard spots—rather than sensitive and soft. One final criticism is that the tree shapes themselves are repetitious in design and size.

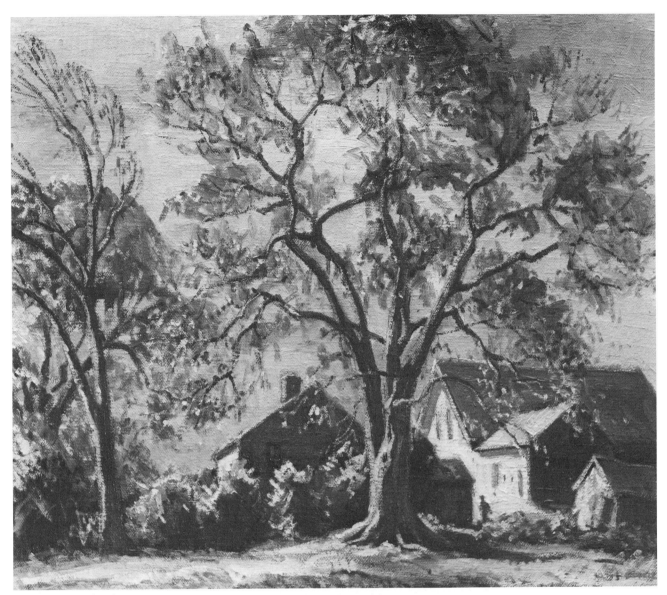

THE MAJESTIC ELM. *Oil on canvas, 20″ x 24″. Courtesy of Dr. and Mrs. Albert G. Gosselin.*

SOLUTION

Here you can see the proper relationship of the trunk and branches to the tree as a whole. In the autumn, when a tree has lost much of its foliage, we have a greater chance to study its skeletal structure. First, the tree should swell up out of the soil, showing the roots that spread out and hold it, rather than coming up straight, like a telephone pole. Regardless of how massive you *know* the trunk is, relate it to the entire width of the foliage spread. Then, the limbs have to have a gradual diminution—too much or not enough is bad. The fine branches at the perimeter are mostly suggested with loose brushwork, but if done properly, the viewer almost "sees" them all. Notice the diversity of design in the trees—this is such an important element in good painting.

This solution painting contains some other subtle improvements on the problem painting opposite. For example, here the sky was held down in value so that lights on the trees and buildings are actually lighter than the sky, as discussed in Key No. 35. Another important change is that here the house on the left is depicted exactly how it appeared. The edge of the roof and the gutter along the side actually make a continuous straight line. No roof shows. I often find students unconsciously changing this, handling it as in the problem painting. They seem to just have to show that the house has a roof, even if they cannot see it.

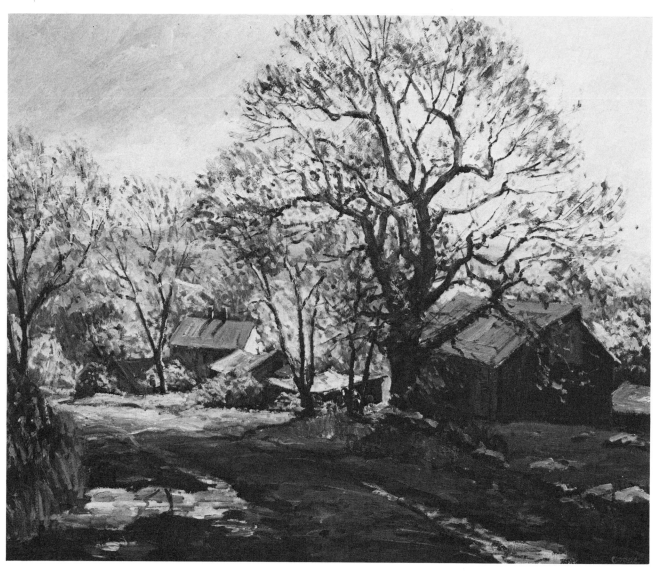

AFTER THE STORM. *Oil on canvas, 24″ x 30″. Courtesy of Mr. and Mrs. Theodore S. Daren.*

Skies

When it comes to skies, there is no doubt that here nature puts on her greatest display of virtuosity. There seems to be no limit to their moods and variations. Actually some artists such as Eric Sloane have specialized in painting what they call "skyscapes," and have shown us the tremendous possibilities that exist in this single field.

This section is a good place to mention a concept recognized by all artists: when compared to the *real thing*, a painting always looks inadequate. Nature, with its range of tonal variations, is like a maestro playing on the keyboard of a grand piano, while we, with our limited palette of paints, the equivalent of a child's toy piano, are trying to imitate his performance. Only when you get the canvas home, away from reality, can you begin to recognize if your humble efforts have been successful.

In this section we are dealing briefly with the two primary approaches to painting skies: either the sky is a dominant factor and the main theme of the painting, or it plays a subordinate and complementary role to the landscape. I can honestly say that not always does the ideal solution to a sky come along while you are painting a landscape. What you actually have to do is to figure a theoretical solution in terms of color, pattern, and value to your sky and then design the composition of it accordingly. This is why you must *know* skies and be able to fabricate one just as though it were actually there. To facilitate this, I strongly advise many hours of studying and sketching them. I have found pastels excellent for this purpose because you can work rather rapidly with the medium.

47. Keep the Sky Lighter on the Side of the Source of Light

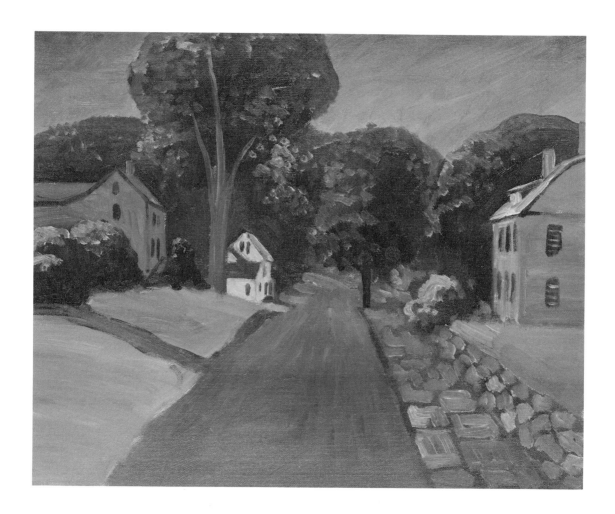

PROBLEM

In most students' work, there is very little evidence of light on the subject. To achieve a feeling of light, you have to use every means at your disposal—a very simple device is adjusting the values in your sky. The next time you are outdoors painting, notice that the sky is usually lighter closer to the sun and grows increasingly darker as you look away from the sun. Because of clouds, or other atmospheric conditions, this principle may not always appear to be true, but most of the time it is. What a simple device to help the feeling of light in your painting! Look at the paintings reproduced in this book and see how often I have used this theory to advantage. Try to visualize how these paintings would look if I *had not* used it—much less effective, as we see above.

This subject gives us an opportunity to bring out other typical mistakes an amateur makes. The road is designed right up the center of the picture, and nothing has been done to make it lie flat or modify the directional thrust. In handling a flagstone walk, such as the one to the right of the road, the student is usually too conscious that it is made up of large squarish stones. He does not design them flat enough so they lie down. Similarly, the stone wall is not handled sensitively enough—it should be painted with a feeling of form to the structure, and not, as I tell my students, "like a bunch of dinosaur eggs piled up."

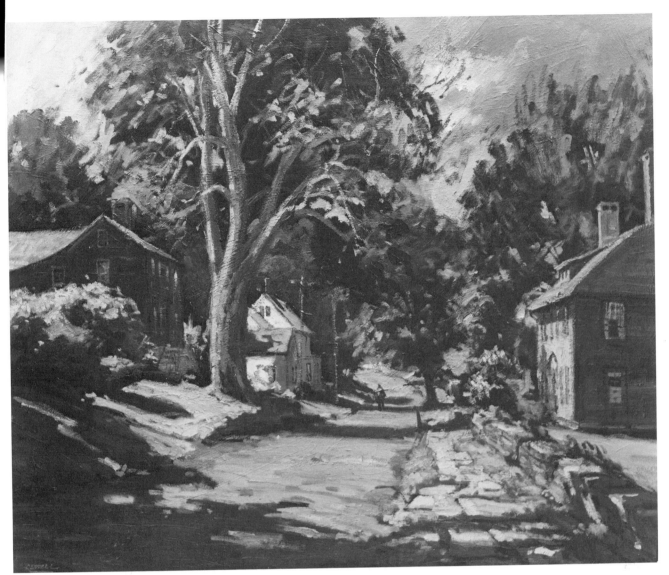

WASHINGTON STREET, NORWICHTOWN. *Oil on canvas, 24″ x 30″. Courtesy of Judge and Mrs. Philip M. Dwyer.*

SOLUTION

In all my paintings, you will be very conscious of the drama of light. It comes from a definite direction and plays over the forms in an interesting and artistic manner. To show the viewer *where* the light is coming from, I quite often paint the sky lighter on the side closest to the sun. Compare these two paintings and see how I have handled the sky to advantage in the solution. Like all rules in painting, they are made to be broken, and I do not prescribe this in every case, but notice how often I do use it and how it does help.

Let me go over other things I have done here that bear emphasizing, even though they are discussed in other keys.

You should always choose a time of day when the light on the subject creates not only form but beautiful patterns. The foreground shadow pattern—which incidentally is entirely out of my imagination—is designed not only to soften the thrust of the road, but to convey a feeling of form to the terrain. Notice how the shadow pattern flows down the bank on the left, splashes decoratively across the road, and climbs up and over the stone wall on the right. Throughout the painting I always consciously played lights against darks. The windows in the house on the left are suggested by flecks of light colors echoed from other parts of the composition.

48. Make Skies Interesting without Competing with the Landscape

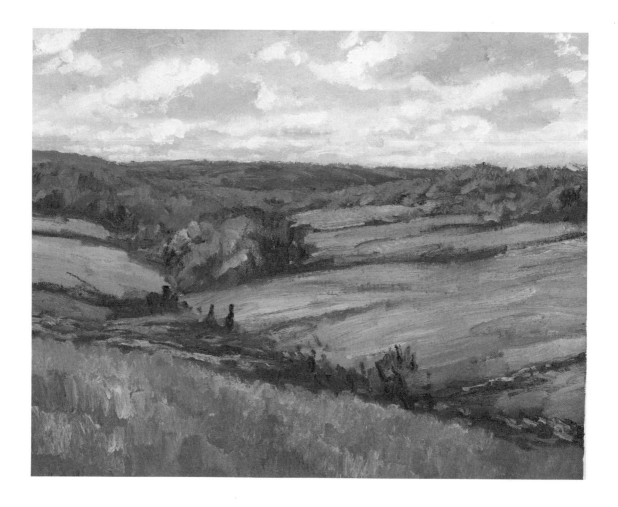

PROBLEM

Here we have a scene of the rolling Connecticut hills, and the canvas is divided almost equally in thirds—foreground, hills, and sky. In making a painting, the artist should decide what is the prime message he is trying to get across and subordinate secondary themes. The motif here should have been the hills, but the sky is upstaging them and diverting too much attention away from the center of interest. (Just the other day I saw this mistake made in a portrait, where the suit of clothes attracted more attention than the face. You see, basic principles apply to all types of painting.)

As a sky, this one is not too bad. There is a progression of cloud sizes that make the sky recede, and the overall design is reasonably good, but still the sky is overly important and attracts undue attention in a landscape that is not basically a sky painting.

As a painting, this is a rather ordinary solution and rendition. The illumination is the same all over, there is not enough progression of values to exploit aerial perspective, and the distant hills are almost the same value as the foreground and middleground.

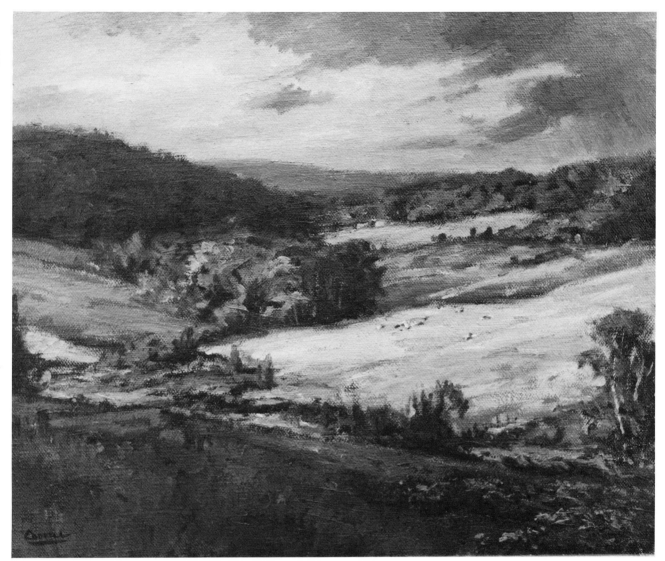

CONNECTICUT HILLS. *Oil on canvas, 16" x 20".*

SOLUTION

The theme here is "the hills" and that is what we want the viewer to see. In fact, I even narrowed it down to just a certain part of the hills—the ones in the right middle-ground—and I subordinated all the rest. This is achieved by the same principle I took up in the key dealing with cloud shadows—parts of the terrain can be kept in shadow while others are bathed in light. The result is a far more interesting and dramatic solution than the painting opposite. Here you see the foreground entirely enveloped in cloud shadows; as a consequence, the eye goes right over it to the hill in the middleground, which is enhanced as the center of interest by a few dabs of color suggesting cows grazing on the slopes. The hill on the left is also painted in cloud shadows so it will not compete.

Although all this is brought about by a sky filled with clouds, the point to remember is this: make the sky interesting, but not so interesting that it upstages the main theme. Notice that I designed the flowing sweep of the sky to complement the diagonal thrust of the foreground hill. I also placed a tree in the lower right hand corner; this addition makes the design more interesting and stops the viewer's eye from sliding out of the picture.

49. Paint a More Dramatic Sky than the One Actually There

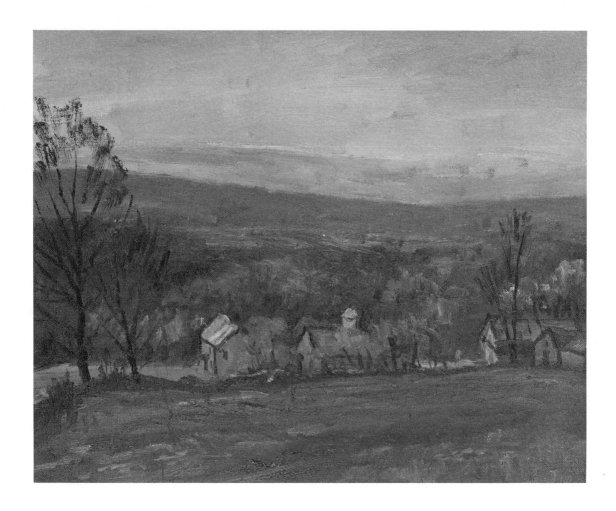

PROBLEM

One spring day a few years ago, I was out with a student who had come East to study with me privately for a week. It was cold, raw, and overcast—a day I am sure he would not have chosen to go out painting by himself. The sky was flat, gray, and uninspiring, with no direct source of illumination. Just soft, flat light filtering down from the leaden sky. Under such conditions it is always difficult for the average student to realize the possibilities that exist. In this key I have not made the problem painting radically different from the solution, as I wanted to first show you how the sky really looked, and then what I did to improve it. A be-

ginning painter must realize he cannot expect to give a subject such as this the interpretation that the professional can with the knowledge gained through years of experience. Throughout the book I am constantly aware of this fact, but I believe that these basic keys applied to your paintings from the very beginning will immeasurably help you to achieve your goal—painting successful landscapes. Here no attempt was made to improve the sky that existed, and as so often happens, the distant hills form an almost completely repetitious line of the middle distance. It is amazing how often the student repeats lines as you see here.

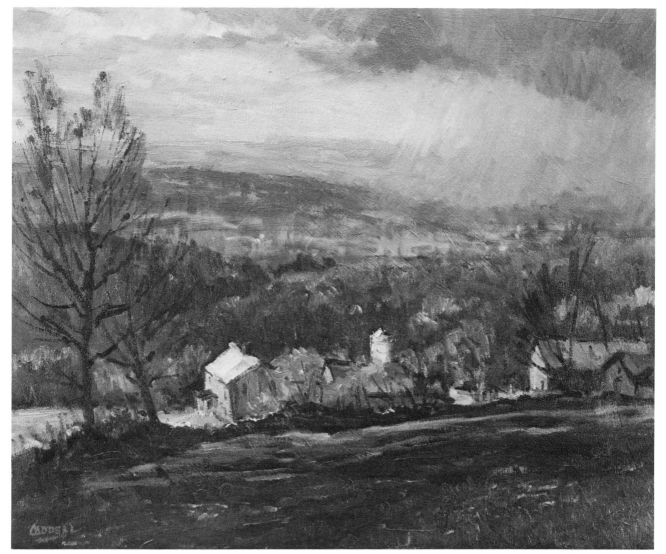

SPRING IN THE VALLEY. *Oil on canvas, 16" x 20". Courtesy of Mrs. Foster Caddell.*

SOLUTION

To create a bit of drama and make this painting more interesting. I imagined that the sky might be broken up a bit and just possibly the sun could poke through momentarily. An effect like this of course has to be painted from memory and experience, which reiterates my philosophy that to paint well, one must paint—paint—paint! I restricted the light to the area containing the farm buildings; this gave me a bit of contrast and color at the center of interest. Now for the sky—why have something monotonous if it can be made interesting without rivaling the main focal point?

Some breaks in the clouds and a suggestion of a rain shower softening the last range of hills is the answer. Who ever said that realistic landscape painters copy nature? We are as creative as any other painters! I only wish that you could see this in color with the tender, green buds coming out against the purple haze of the hills. It was painted very spontaneously in just one afternoon and not touched afterwards. Upon seeing it, my wife insisted it become part of her collection, and, as she is my best critic, I knew it had succeeded.

50. Vary Cloud Shapes for Better Design

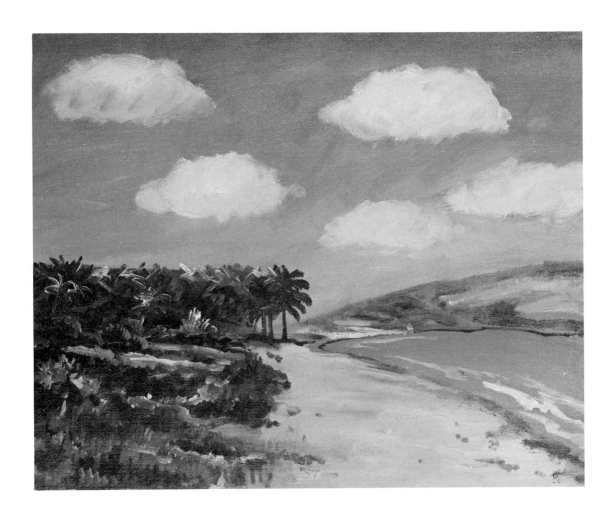

PROBLEM

A characteristic trait of amateur painting is a plain, blue sky that hangs down behind the scene like a flat, blue curtain. When the novice has the courage to introduce clouds in his painting, they are usually symmetrical puffballs of cotton, as we see here. In addition, the clouds are placed at too regular intervals in the sky area, and they do not exhibit the progression in size that would make them recede into the distance.

Let us go over the other definite "wrongs" in this problem painting. First, the composition is divided too equally between sky and land—one rivals the other for the viewer's attention. Then in the foreground, the beach is divided equally between sand and shrubbery and the line of the water comes directly out of the lower right corner of the composition. There is little variety in the design of the palm trees and we zero in on the one directly in the center, with the branches shaped like big bananas. This was one of the most delightful spots I found on a sailing vacation in the Virgin Islands—it reminded me of the lovely islands in the South Pacific. And this key brings out another point that the amateur must learn: no matter how lovely and fascinating the subject is, if it is not handled well, it can result in rather a sorry painting.

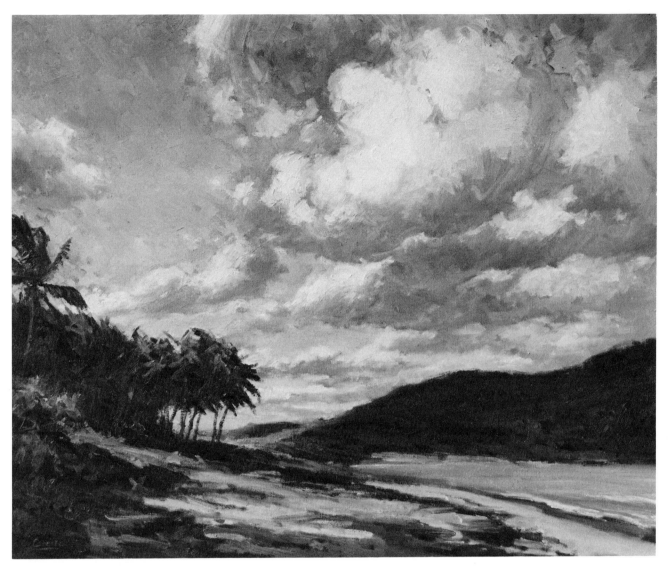

PETER ISLAND, B.V.I. *Oil on canvas, 24″ x 30″.*

SOLUTION

The big decision in your painting should be: are you saying sky or are you saying landscape? In most of the paintings in this book, I have stressed holding the sky down so that it complements, but does not upstage, the rest of the painting. When you do decide to go all out and paint a sky, subordinate the landscape. Here most of the canvas is devoted to the sky, with only about one-third given to the land area. I have kept the viewer's attention primarily up in the sky by throwing much of the land in shadow. Notice how part of the sky is open and cloudless, and part of it dense and cloudy. The sky is actually a great, big abstract design made up of clouds and blue sky. Note especially how these clouds become larger and taller as they get nearer to us, and how they recede into the distance, one behind the other. Cumulus clouds like these should not look like cotton puffballs. Instead, they should be flat-bottomed masses, with form and modeling and a definite shadow side. They should also be diversified in shape and design.

Clouds have a specific form and structure—you should make studies of various types. I have sat for hours making notes of their many moods and changes in order to build up a backlog of knowledge about them.

Conclusion

In closing, there are a few thoughts I would like to leave with you.

We do not all start out with studios that have a wonderful north light—it is usually the reward after working hard for years under less than ideal conditions. Do try, however, if it is at all possible, to set aside a room or part of a room as a working area for yourself. I think this is extremely helpful and important.

Learn to recognize good painting. Go to museums and exhibitions and study work that makes a definite impression on you. Try to analyze what the artist did and why. If you can "read" the painting, you can learn a great deal.

Gradually develop a library of good books on art and painting. We are fortunate today to have so many fine books available, and the quality of reproduction is so much better than it was years ago.

Seek out and obtain the help of a good teacher. There is an old saying, "He who is self-taught has had an ignorant teacher." There have been artists who have made it entirely on their own, but, believe me, there are very few. Life just is not long enough to figure out all your mistakes by yourself. I grant you there are not too many good teachers who can not only paint well, but have the patience and ability to communicate their knowledge to their students. They do exist though, so do not settle for just anyone who hangs out his shingle.

You undoubtedly realize that art is as diversified as religion. There are so many different cults, claiming theirs is the right answer. Sooner or later, you must make up your own mind as to what you think is great art, and have the courage of your own convictions to stick to it. So many artists are overly concerned with what type of painting is "in." They paint in a certain style or manner to get accepted in certain exhibitions, or to catch the attention of an art critic. Another old saying, although facetious, has a great deal of honest logic: "No one ever built a monument to a critic." I long ago decided on the path I thought was right for me, and stuck to it, regardless of whether it was "in" or "out."

I have not been affected by the gimmicks, crudity, and superficiality of many modern trends; to me art should be the searching for beauty and truth. I strive for a classical timelessness that will, I trust, stand long after trends and vogues will have passed into history, and future generations will wonder how they ever could have existed at all. I seek beauty in a time when many are afraid to admit it, fearing they would be termed "square" and out of step with their time.

I place great importance on the craft of painting, for without it I could not fully convey my emotional reaction to visual stimuli. I try to take the ordinary in life and make it extraordinary by the way I portray it. I seek to capture a mood, either in a landscape or a figure study, and transmit this feeling. To me art is first and foremost a means of communication between the artist and the viewer.

I am fortunate in getting great pleasure from painting a wide range of subject matter. I can get as enthused about a landscape as I can about a formal portrait commission. Every time I make a painting it is a great experience, and even though I am known as a teacher, I learn something new each time I pick up a brush.

Index

All entries in *italic* refer to finished paintings by Foster Caddell.

Accentuating detail, 45–57
Aerial perspective, 104–105, 124
After the Shower, 139
After the Storm, 148
Atmospheric distance, creating with color, 104–105
Attention, capturing viewer's, 46–47, *See also* Center of interest; Directional lines; *and* Focal point
Autumn Hillside, 57
Autumn Mosaic, 94
Autumn Patterns, 103 (color)
Autumn Splendour, 93, 119 (color)
Autumn Tapestry, 127 (color)

Backlighting, 122–123. *See also* Cloud shadows; Dramatic lighting; *and* Light(s)
Beach Dale Lane, 83
Black, 21
Brushes, 21
Buildings: emphasizing dark shadows on white, 80–81; sunlight patterns on, 116–117

Caddell, Foster, biography, 13
Canvas. *See* Surfaces
Cast shadows, utilizing on trees, 82–83. *See also* Darks, played against lights *and* Dark shadows
Center of interst, one, 42–43. *See also* Attention, capturing viewer's; Directional lines; *and* Focal point
The Center School, 59
Clark's Falls Grist Mill, 43
Cloud(s): colors in white, 114–115; varying shapes of, 156–157
Cloud shadows: using dramatic, 90–91; using to emphasize foreground, 92–93. *See also* Backlighting *and* Dramatic lighting
Color(s), 21, 23, 95–128; creating atmospheric distance with, 104–105; harmonious, 102–103; in moonlight, 108–109; warm, in summer painting, 106–107; in water, 110–111; in white clouds, 114–115; in white snow, 100—101
Color chart, 23
Color palette, 21, 23
Connecticut Hills, 153

Cool shadows, in sunshine, 112–113
Corot, Jean Baptiste Camille, 79

Darks, played against lights, 66–69, 120–121. *See also* Cast shadows *and* Dark shadows
Dark shadows, emphasizing, on white buildings, 80–81. *See also* Cast shadows *and* Darks, played against lights
December Drama, 53
Depth, creating: by diminishing sizes, 130–131; by strengthening foreground detail, 134–135
Design, simplifying, 50–51; to accentuate detail, 56-57
Dimishing values, to create distance, 132-133
Directional lines, 48-49
Distance, creating by diminishing values, 132-133
Dramatic lighting, in foreground for shadows, 88–89
Dramatic possibilities, using, 40-41
Dramatic sky, 53, 154-155
Dramatize, using cloud shadows to, 91-91
Drawing, 37-61; initial design on canvas, 26

Easels, 21

Farm in Escoheag, 45
February Morning, 75
Figure, adding life with a, 58–61
Flats. *See* Brushes
Flesh colors, 21
Focal point, 78-79; in distance, 138-139. *See also* Attention, capturing viewer's; Center of interest; *and* Directional lines
Foreground, emphasizing, with cloud shadows, 92-93
Foreground detail, strengthening to create depth, 134–135

Gardener's Hill, 115 (color)

Harris, G. Gordon, 17
Helck, Peter, foreword by, 13
Horizon, placement, 126–127
How Dear to this Heart, 55

Illustration, painting as, 33-35

The Johnson Place, 113 (color)

Lacy Elms, 142
Lane to the Hermit's Place, 145
Laying in tonal values, 27
The Lewis Mill, 12
Light(s), 63–77; indicating, 28; limited, 72–75; played against darks, 66–69; in sky, 150–151; using to create mood, 69. *See also* Backlighting; Cloud shadows; *and* Dramatic lighting
Lighting: choosing the best, 64–65; dramatic, in foreground for shadow, 88–89
Lights and darks, grouping to organize, 70–71
Lilac Time, 87
Luminosity, in shadows, 86–87

The Majestic Elm, 147
Materials, 21-23
Michelangelo, 15
The Mill Cottage, 18
Miscellaneous materials, 21, 23
Moonlight, color in, 108–109
Morning Light, 128 (color)
Morning Mist, 123 (color)
Morning on Bay Street, 49
Mystic Harbor, 41

Narrative painting, 54–55
New England Motif, 91

October Sunshine, 121 (color)
The Old Mill Stream, 105 (color)

Painting palette, 21
Palette: of colors, 21, 23; painting, 21
Pastel Study of Elm Tree, 31
The Patriarch, 22
The Patterns of Spring, 24
Perspective, 44–45, 116; aerial, 104–105
Peter Island, B.V.I., 157
Phillips Pond, 89
Planes, maintaining distinct spatial, 126–137
Procedures, painting, 25–31

Quiet Brook, 51, 135

Redesigning subject matter, 38–39
Regal Victorian, 85

Roads, designing, 124–125. *See also* Shadows
Rolling Hills, 133
Rural Gothic, 99 (color)

School's Out!, 36
Shadow(s), 79–93, 95, 128; cast, utilizing on trees, 82–83; cloud, emphasizing foreground with, 92–93; cloud, using to dramatize, 90–91; cool, in sunshine, 112–113; dark, emphasized on white buildings, 81–81; in foreground for dramatic lighting, 88–89; luminous, 86–87. *See also* Roads, designing
Shadow directions, making consistent, 84–85
Shady Lane, 131
Shimmering Light, 137
Simplifying design, 50–51
Sketch Box, French, 21
Skies, 149–157; darkening, to dramatize light object, 120–121; dramatic, 154–155; not competing with landscape, 152–153
Snow, colors in white, 100–101
Space, 129–141

Spatial planes, maintaining distinct, 136–137
Spring in the Valley, 155
Storm's End, 47
Story telling, in painting, 54–55
Subject matter: choosing the best lighting for, 64–65; redesigning, 38–39; varying solutions to same, 52–53
Summer Afternoon, 67
Summer Morning, 73
Summer painting, warm colors in, 106–107
Summer Reflections, 111 (color)
Summer Road, 78
Summer Stream, 71
Summer Tapestry, 107 (color)
Sunday Afternoon, 62
Sunlight, 128; patterns on buildings, 116–117
Sunshine, cool shadows in, 112–113
Sunshine and Shadows, 117 (color)
Surfaces, 21

Tonal climax, making focal point a, 76–77
Tonal harmony, 98–99

Tonal values, laying in, 27
Tranquility, 77
Tree(s), 143–147; and cast shadows, 82–83; shapes, 144–145; trunks and branches related to whole, 146–147

Up For Repairs, 14

The Valley Road, 125 (color)
Values, laying in, 27
Vantage point, unusual, 40–41

Warm colors, in summer painting, 106–107
Washington Street, Norwichtown, 151
Water: color in, 110–111; distant, 141; wind ripples on, 118–119
White, 21
White clouds, colors in, 114–115
The White Mill, 81, 97 (color)
White snow, colors in, 100–101
Wickford Cove, 141
The Widow's Walk, 69
Wind ripples, on water, 118–119
Winter at Clark's Falls, 101 (color)
Winter Marsh, 52
Winter Nocturne, 109 (color)

Edited by Claire Hardiman
Designed by Bob Fillie
Set in 10 point Laurel by Publishers Graphics Inc.
Color Printed by Toppan Printing Co. (U.S.A.) Ltd.
Printed and bound by Halliday Lithograph Corp.